We the People

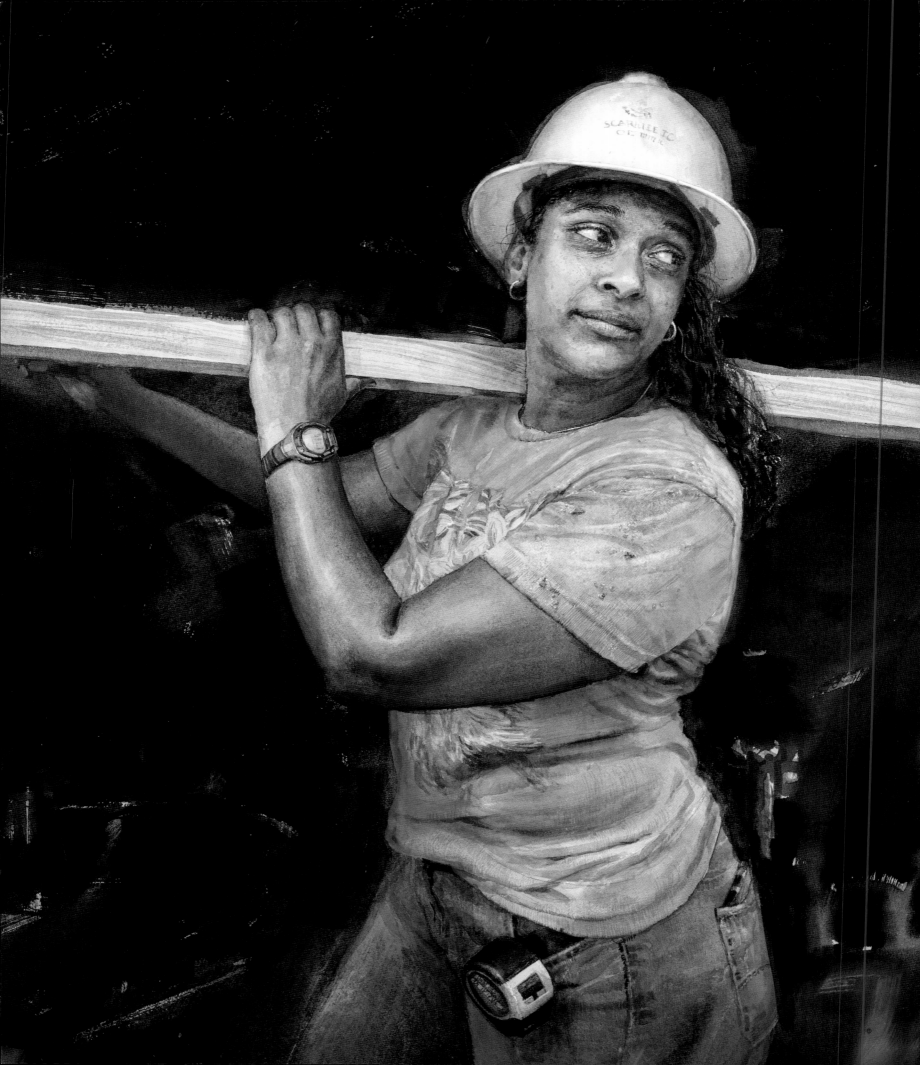

WE
THE
PEOPLE

Portraits of Veterans in America

MARY WHYTE

THE UNIVERSITY OF
SOUTH CAROLINA PRESS

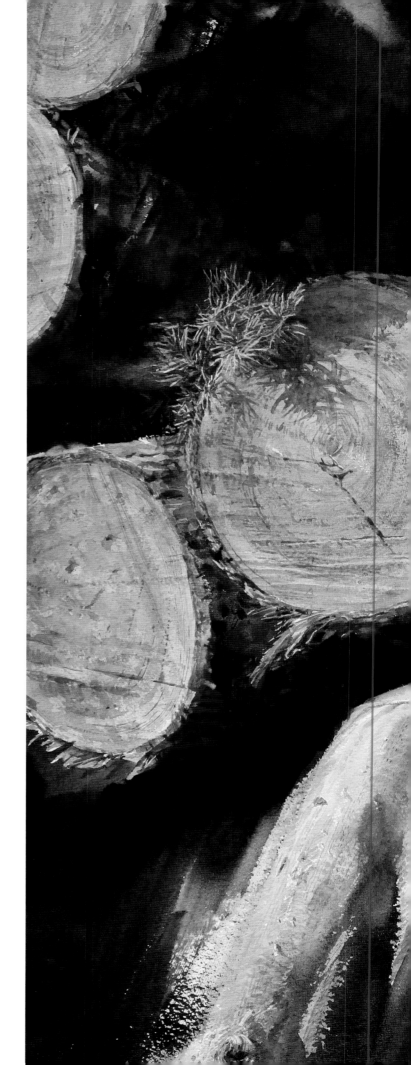

WE THE PEOPLE

Published by the University of South Carolina Press
Columbia, South Carolina 29208
WWW.SC.EDU/USCPRESS

Designed and typeset by
Nathan Moehlmann,
Goosepen Studio & Press

Manufactured in South Korea

28 27 26 25 24 23 22 21 20 19 10 9 8 7 6 5 4 3 2 1

Library of Congress Cataloging-in-Publication Data
can be found at http://catalog.loc.gov/.

ISBN 978-1-64336-011-9 (cloth)
ISBN 978-1-64336-012-6 (paperback)
ISBN 978-1-64336-013-3 (ebook)

Display illustrations (details): frontispiece, *Counterbalance*, 2018;
pp. iv–v, *Roller*, 2015; pp. vi–vii, *Window*, 2016; p. x, *America*, 2017;
and pp. 14–15, *Crescent Moon*, 2018

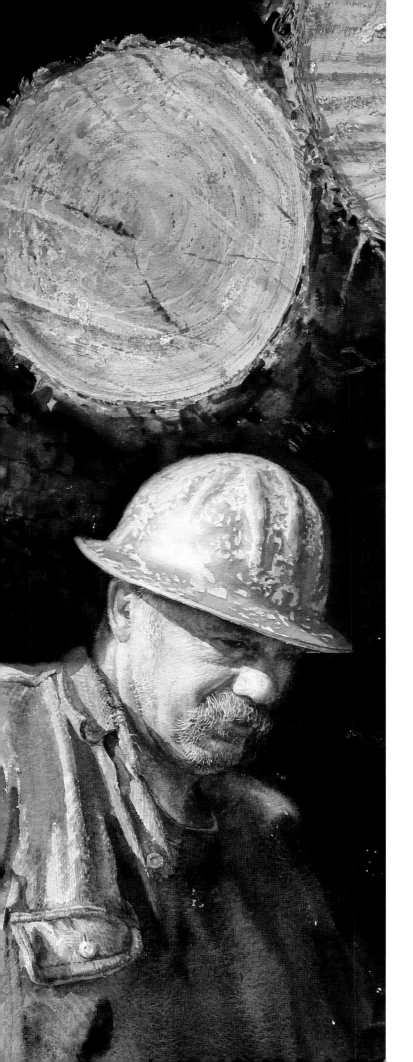

To all who have served

"No one has greater love than to lay down his own life for his friends."

JOHN 15:13

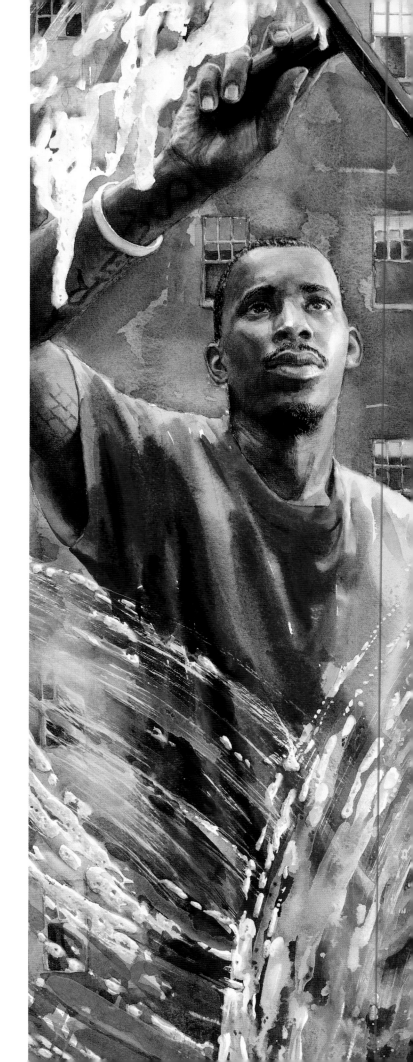

CONTENTS

ACKNOWLEDGMENTS

Special thanks go to President George W. Bush, Sharon Crawford, Tracy Culbertson, Dr. James Yanney, Michael and Dr. Gail Yanney and family, Jan Fritsen, Kathie Bennett, Debbie Geffken, Cathy Marino, Lisa Quadrini, Helen Hill and the Charleston Area Convention and Visitors Bureau, Michael Bennett, Rick Jerue, Mayor John Tecklenburg, William "Terry" Bare and the Veterans Transition Center of Monterey County, Linda Fogle, Dr. Richard Brown and the editors and staff of the University of South Carolina Press, photographer Jack Alterman, the Wexler family, Carol Barnes, Doug Benefield, the Charleston Symphony Orchestra, Carmen Gardner, State Representative Nancy Mace, George Patton Waters, W. Thomas McQueeny, General and Mrs. Glenn M. Walters, Tiffany Silverman, Suzanne Kerver, Sarah Myles, Pamela Anderson, Chris Weatherly, Preston Harrison, Ranel, Beverly and April Parks at Athens Framing Gallery, Bob Harris, Anne Quattlebaum of the Charleston City Waterfront Gallery, Frank Russen of the Principle Gallery, Jonathan Nichols, Nancy Gregory, Sam Baker, David Nixon, Susan Marlowe, Major General James E. Livingston (Medal of Honor), Ron Small, Bob and Karen Webster, John and Mary Lou Barter, and especially the veterans and their families who shared their stories and were the inspiration for this book.

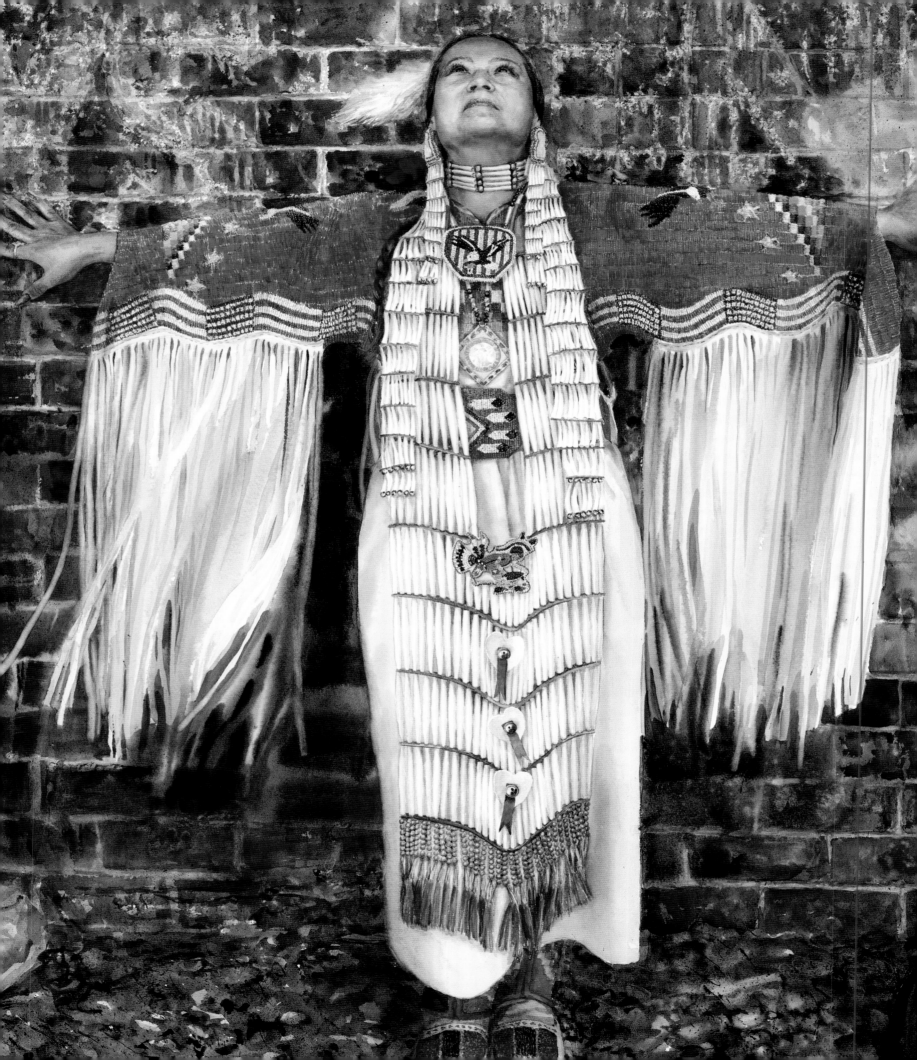

Introduction
A Call of Duty

"Freedom is never more than one generation away from extinction. We didn't pass it to our children in the bloodstream. It must be fought for, protected, and handed on for them to do the same, or one day we will spend our sunset years telling our children and our children's children what it was once like in the United States where men were free."

RONALD REAGAN,
address to Phoenix Chamber of Commerce, March 30, 1961

In many communities across America there are men and women who go about their days with quiet resolve and little expectation of accolades or recognition. They are the folks whose days are marked by the cows milked, patients seen, corn harvested, test papers scored, engines rebuilt, and children fed and put to bed. They generally go about their lot with steady purpose and without complaint, neither cutting corners nor cutting out early. They are perplexed by those seeking attention in a media-obsessed world and are sustained simply by knowing that theirs was a job done well and with honor. When asked why they took the path they did, some answer because their fathers chose this way. Some say it was because they had no other options. And others say it was because they wanted to make a difference in a challenging world. Regardless, whether by purpose or by accident, almost everyone I spoke to, including those I painted for the *We the People* project, told me that serving in the military ultimately changed them and made them a better person.

Although I could not have known it at the beginning, what I experienced over the seven years I spent traveling the country and painting veterans would change my own life in unimagined ways, too. There were personal setbacks, financial concerns, and many promising plans that imploded. Paintings that took weeks to complete ended up being purposefully destroyed, then started anew. Ideas that had been sketched out and taped to the wall of my studio were tossed and replaced with others that reached deeper. The seemingly endless uncertainties, dead-end leads and unreturned phone calls finally began to come together, unleashing a cascade of newer ideas and energy. Traveling by myself to distant and unknown regions of the country may have seemed ill advised to others, but for me it became a wonder-filled expedition to the uncharted. I never knew in advance, one day to the next, where I would end up in each of the fifty states, or how I would get to my ultimate destination. And I certainly could never have imagined that, in addition to cars and airplanes, my means of transportation would also include a ferryboat, lobster boat, eighteen-wheeler, harbor patrol boat, cruise ship, taxicab, firetruck, motorcycle, three-wheeler, helicopter, pick-up truck, flatbed truck, plumbing truck, and a very, very slow golf cart. *We the People* was the most unplanned, the most haphazard, and the most exhilarating adventure of my life.

It all started seven years earlier. I was driving west across Georgia with my friend Debbie, heading to an art center near the Georgia-Alabama line where I was to appear for a talk and book signing for *Working South*, my latest exhibition. It was late summer, and the fields were as brown as a grocery store's paper bag, flattened and limp from the relentless scorching sun and humidity. In the small towns where we stopped to find a diner or gas station, the sidewalks were empty. Stores displaying pale, scuffed mannequins clothed in sequined T-shirts might be next to a shop with a hand-lettered sign saying WE BUY GUNS. At a gas station we spotted cases of a favorite white wine, stacked in the back of the store next to the beef jerky and fishing bait. At ten dollars a bottle, we bought almost all the owner had and giddily loaded it into the back of the car. It was a small win to offset the perspiration pooling in the hollows of our necks and soaking our backs. Even though the aging Volvo's air-conditioner had quit working the first hour of the trip, I periodically flipped the dial toward blue, hoping. I finally relented and turned up the radio instead.

"So, Mare," Deb chirped, attempting to divert our attention from the oppressive steam bath while an insistent deerfly circled around our heads. A drop of sweat trailed down the side of her face as she swatted the fly out the window. "Now that *Working South* is done, what are you going to paint next?"

I chuckled. In recent weeks we had spent many hours brainstorming what my next painting project might be. My last series, published as *Working South*, depicts blue-collar workers in vanishing industries. The collection had toured five museums and was now nearing the completion of its tour. Based on museum attendance, the exhibition was a success, bringing in largely working-class men and women curious to see paintings that looked like them. Although I didn't anticipate it when I started *Working South*, the paintings turned out to be a great source of pride and encouragement for my models. As everyday folks accustomed to being overlooked, the attention given to them proved to be a great validation of their work and self-worth. Algie, a reclusive, sixty-year-old river man, summed it up best when he said, "I have gone my entire life without anyone ever paying any attention to me. Who would have thought a little nobody like me would be the subject of a painting? It just goes to show you that God sees us all."

Now that the last series of paintings was behind me I was ready for something bigger, wider reaching, and more challenging.

For a long time, I had considered going back to Kenya to paint the people in small villages I had once visited, but I decided against the idea after seeing too many other representations of the same subject. Deb and I tossed around ideas. Paintings of northern blue-collar workers, or a series about musicians, or chefs, or minimum-wage earners. What about the elderly? Perhaps a series of paintings of men and women over eighty? I had even thought about doing a series of paintings of people in the remote areas of China. But what did I know of such people? And how could I possibly paint, with authenticity, folks that I couldn't converse with? All the ideas seemed contrived or unoriginal, or, at the very least, limited in depth. I decided that I wanted to do a series of paintings that were truly American. I wanted it to be a work that, when gathered together, would be an honest, collective portrait of our country. And I would be able to visit every state in the country, once an elusive dream.

As with many of my ideas, the one for *We the People* appeared unexpectedly like a bird through a cloud. What began as a tiny fledgling of an idea immediately spread its wings wide. The power of the feeling took hold of me.

"What about veterans?" I blurted out. Although I was never in the military, both of my parents had served in the Red Cross during World War II.

"Hasn't that been done already?" Debbie responded.

"Yes," I said, my next project becoming clear to me. "But not if I approach it in a whole new way."

Before embarking on such an ambitious undertaking, I needed to know how former servicemen and servicewomen might view my project. With more than twenty million veterans in this country, it was important to me that this project be honorable to them. I headed to the homeless shelter called One80 Place in Charleston,

where food, shelter, and hope are provided to many folks, including veterans. It was Wednesday night, and there were nine men already sitting on folding chairs in a circle for a session with a counselor. I sat down and introduced myself by showing the men a book of my work.

"These are paintings?" asked one man, pushing up his thick glasses and peering more closely as he turned the pages of the book. "My cousin, he's a real good artist. The guy can draw anything. He can draw Garfield like it's the real thing."

"I could draw in high school," said another man who was wearing a faded camouflage sweatshirt. "But that was it. Never did nothin' with it after that."

The youngest veteran, a thin man with dark eyes and rounded shoulders wearing a black T-shirt, reached into his backpack and shyly produced a tattered sketchbook. He had been told by the staff that a professional artist was coming to talk to the group. He held out the book to me, exposing scars on the inside of his arm. Inside the album were numerous pencil drawings of women's faces, done with tentative, delicate lines.

"Dude," one of the men said, grabbing the sketchbook and holding it at arm's length for a better look. "You did these? Man, I wish I could do art like this."

As the men passed around the young man's drawings, I told them about my project, of how I wanted to do fifty paintings of veterans, one from each state in the country. I would include men and women of all ages and from all walks of life, creating what I hoped to be a cumulative portrait of America. As I talked, I watched and listened carefully for their reactions.

The men seemed excited that a real artist would choose to paint everyday veterans, especially after they had reintegrated back into society. As the conversation gained momentum, the group offered up suggestions for subject matter based on their own experience: a construction company owner, insurance salesman, dishwasher, or maybe a cab driver. One man, with a leather jacket and frayed, brown baseball cap sat with his fingers woven tightly together, never saying a word. His eyes remained empty, fixed on something far in the distance. I would soon learn to recognize the "thousand-yard

stare," that vacant look of a light gone out in a soldier who had witnessed, first hand, the horrors of war. As a doctor friend explained to me later, the phenomenon of the vacant gaze was the body's way of shielding the mind from what was just too much to handle. Termed "shell shock" in earlier wars, now commonly referred to as post–traumatic stress disorder, it is malady far too common today in a world ravaged with bloodshed and conflict.

"Tell me," I asked, forging on, "What do you think is the most important thing for me to include in all of the paintings?"

"That you get us from the top down," answered one of the oldest vets, a pale man with wisps of silver hair that dangled like yarn around his shoulders. He had once been a warehouse supervisor with a family, but for the last fifteen years lived alone on the streets.

"The top down?" I questioned, writing the words in my notebook.

"Yeah," he said. "It's important that you paint all of us. From the ones at the top, like mayors and successful people, to those of us down here at the bottom," he said gesturing around the circle of men. They murmured in agreement.

Without shifting his eyes, the man in the brown baseball cap nodded once.

It was all I needed.

The next day I got to work.

I started by outlining a black-and-white map of the United States and hanging it on the wall of my studio. My idea was to meet with each selected veteran; do the preliminary sketches, notes, and photographs; and then color in that person's state with yellow. Then, after each painting was finished, I would paint over the yellow with red, so that in the end I would have a complete map of the country all in crimson.

That was the easy part. I remember standing back and looking at my freshly created map of the fifty states, and then realizing that turning the states to yellow and then to red was going to be a lot of work. A whole lot of work,

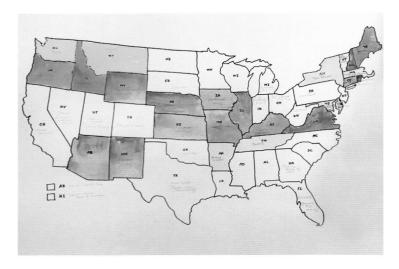

I used the map to track my progress. It was exciting to see the states gradually being filled in with color.

thousands of hours, and miles upon miles of travel. And how was I going to afford the travel to all fifty states?

For some time in my career, I have often received requests to teach classes across the United States and abroad. Using that, I figured I could get to most of the veterans by booking painting classes in numerous locations around the country. That way, at least part of my travel expenses would be covered. Over the next several years, I scheduled workshops in various cities including Las Vegas, Gloucester, Houston, Seattle, Carmel, Santa Fe, Columbus, Bend, and Scottsdale. To get to Hawaii, I scheduled a class on the island of Maui. After the workshop was over, I navigated the black, winding road up the side of the volcano to meet with a Japanese American veteran who had served in World War II. Well into his nineties, Hiroshi, a former carpenter and home builder, patiently posed with his chestnut-colored hands folded in his lap. For a while we sat in his garden under gnarled and bent persimmon and cherimoya trees he had planted over a half century before. Later, leaving our shoes outside the door, we talked in his living room as he told me the story of how he was initially turned down when he tried to enlist after Pearl Harbor was bombed. Suspicious of the

twenty-one-year-old's allegiance, American authorities would wait almost two years before allowing him to enlist as an Army combat engineer in 1943 (*Driftwood*, p. 37).

Hiroshi's life story was one of many that I would hear during my travels. The veterans I painted were all ages, from all walks of life, who had honorably served in one of the five branches of the military (Army, Navy, Air Force, Marines, Coast Guard).

I learned years ago that people are generally very welcoming to artists, and that in many places in this country and around the world, carrying a sketchbook is as good as having a high school hall pass. Just identifying myself as an artist has gotten me entry into many remarkable and otherwise inaccessible venues. I have managed to charm my way into busy restaurant kitchens, tattoo parlors, container-ship yards, textile mills, horse-racing events, ballet rehearsals, and coal mines.

At times, getting access to some of my subjects required a bit of creativity, if not downright gumption. The idea of painting a circus performer appealed to me — however, all of my phone calls to the circus's office inquiring about veterans went unanswered. The next step seemed logical enough to me. I would have to go directly to the source. At the circus I skirted the entrance and worked my way past the cages of pacing tigers. When I was stopped by a stern-looking show boss, I implied that I had spoken with management about doing a painting of someone who was circus worker as well as a military veteran. Admittedly, it was a bit of artistic fabrication, but it worked. I was introduced to Sean, who had spent many years traveling with the circus while working as a clown. A tall, affable African American, the former Marine showed me around the costume areas as he prepared for an evening performance in the ring. I watched, mesmerized, as he created a new persona by applying brightly colored make-up. With two final strokes, he turned the corners of his mouth into a perpetual happy curl. "Yeah," he said tapping his face with a large puff, sending up a cloud of white powder that circled his head, "I traded in my combat boots for big floppy shoes" (*Face*, p. 41).

But perhaps my all-time favorite maneuver was talking my way into the site of a garbage dump in rural Arkansas.

My summer day at the dump happened while I was renting an apartment in Woodbine, Iowa, a location from which I had access to all the midwestern states. While there, I noted a rubbish truck grinding down Main Street, and thought up the idea to paint a garbage-truck driver. That afternoon I researched the names of regional companies and called one owner, learning that the organization had several vets employed as drivers. I made an appointment to drive out to the site, timing it so that I would be there when the dump trucks arrived with their loads.

The dump was located in the rural backwoods, accessible only by long, dirt roads. When I got to the site the manager, a Viet Nam vet with a long gray ponytail greeted me. When I told him about my project, he responded with a lively "*Cool!*" Later he led me to the transfer shed, and introduced me to CH, another Viet Nam vet, who had just pulled in with his full truck.

Confused, I turned slowly in a complete circle. This was the dump? I was not prepared for a transfer station, which is actually clean. It is here that garbage trucks back into a large hangarlike building and tip their loads into a wide crevice. Parked below was an eighteen-wheeler with the capacity to carry the contents of three or four garbage trucks to the actual dumpsite, which was miles away.

Seeing my disappointment, the manager frowned. "This isn't what you expected?"

"Well, no," I said, looking at the swept concrete floor and a salvaged poster of Jesus hanging on the wall. "Not exactly."

"What do you want?"

"What do I really want?" I replied, shifting my camera to my other shoulder.

"Yeah, what do you really want?"

"I want CH to turn his truck around, back it in over there," I said, pointing to the center of the hanger, "and dump his contents out really slowly all over the floor."

The manager and driver exchanged glances, eyebrows lifted. They looked back at me.

"*Cool!*" they both exclaimed in unison.

CH hoisted himself up into the driver's seat, turned the hulking truck around in the freight yard, and, with a shrill beeping, the truck slowly backed onto the hangar's concrete

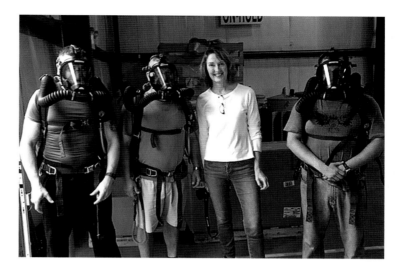

To gain access to coal miners, it was necessary that I pass a safety test on location. Here I am with several of the miners.

floor. I stood to the side, motioning for him to keep going, keep going, and then waved for him to stop.

The immense container powered upward, the rear metal hatch banging open. Mounds of oozing plastic bags, cans, decomposed food, bottles, and stinking filth came tumbling out. Part of a stroller, wads of brown diapers, a deer hide, greasy styrofoam plates, and crumpled holiday decorations toppled over and down, amid a stream of brown mucous slop. The mounds of debris were still moving and sliding downward when CH turned off the truck and got out.

"Well?" he said, grinning, his arms out wide as if ready for a hug.

I surveyed the mounds of slime and slick garbage bags still slipping down, the putrid smell filling my nostrils. I pulled the side of my mouth into a frown, trying not to gag.

"What?" he said, dropping his arms to his sides. "What's wrong?"

"Well," I said looking at the mounds of garbage. "It's not really what I wanted."

"It's not? What do you want?" he asked.

"What do I really want?" I responded, taking my camera out of the bag and motioning towards the mountain

of refuse. "I want you to climb up to the very top and pose for me."

CH pursed his lips and scrutinized the size of the mound.

Tightening his bandana, he nodded, "Cool." He climbed, stepping wide over parts of a vacuum cleaner, a stained woman's dress, and the slimy carcass of a turkey. Then, propelling his arms and moving his legs as if he was swimming, CH worked his way to the top of the reeking mountain of trash, stood up, and struck a pose like Washington crossing the Delaware.

An hour later I was waving goodbye from my car. In my rearview mirror, I could see the backhoe plowing up the mounds of garbage as two men with shovels waved back at me. I had just created a mess bigger than any my own mother could have imagined, and someone else was happily cleaning it up.

Now *that's* the power of being an artist (*Overflow*, p. 23).

Devising an affordable way to travel to distant states brought challenges, Alaska being one of them. So much of the vast state is accessible only by plane or boat. I scheduled a weeklong workshop that was held aboard a Norwegian Cruise ship that left Vancouver and sailed north through the Inside Passage. During daytime hours, twenty students and I were given one of the ship's spacious onboard restaurants to use as our studio as we cruised past enormous glaciers thundering with breaks cascading into the bay. We often saw pods of whales, their backs shimmering like polished ebony stones, gliding just beneath the water's surface. Several of the ship's musicians and vocalists modeled for the group and were easily cajoled into entertaining us during breaks.

Heading north, the ship made scheduled stops in small ports, allowing passengers and students to get off for a day of exploration. While the students went off to shop in the small coastal village of Skagway, I slipped away from the group and headed into town to the small, wood-frame post office. Several weeks prior, over an exchange of emails and phone calls, I had arranged to meet this day with the town's postmaster, Adriane. A fresh-looking woman in her mid-forties, Adriane led me around the post office while telling me about her four years in the Air Force.

"It was a natural fit for me," she explained, as she slung a canvas mailbag the size of a hog over her shoulder. "I wasn't ready for college, and I was used to camping. My dad was a doctor in the military. He's the one who swore me in."

Following her around the mailroom, I negotiated my way over boxes and packages. "What was it really like in the Air Force? I mean, was it challenging?"

"You mean the part about missing my family, or the day I had to find body parts?" she asked flatly, glancing at me as she heaved the sack on to a shelf. "I grew up pretty dang fast" (*Special Delivery*, p. 19).

And grow up they did. Almost all the veterans I spoke with told me that the demands of the military molded them into responsible and disciplined adults. Whether on or off the frontline, soldiers were met daily with challenges that would galvanize them into becoming mature men and women. From the first grueling weeks of boot camp, to the emotional and physical exhaustion of long periods away from the comforts of home, the lessons were ongoing. Whether one wanted them or not, the tests of strength and courage would keep coming. As Eleanor Roosevelt said, "You must do the thing you think you cannot do."

Many combat veterans, including Dan, who fought in Viet Nam's worst battle zones in 1968 and 1969, still harbor painful memories. Carrying a Polaroid camera with his gear into battle, he managed to photograph unspeakable scenes in black and white. Today, the former Marine keeps the photos in a scrapbook hidden away in his home near the wind-scrubbed border of northern Minnesota. In spite of what he had to endure in Viet Nam, he managed to shield his family back in the States from news of the atrocities. "In all the letters home," he said, "I never wrote about death."

Today Dan spends his days as a taxidermist. The nature of the work has helped to quell the symptoms of his PTSD. Thanks to assistance from the Veterans Administration, he retired and was given the means to take taxidermy classes and set up a complete shop behind the home that he shares with his wife. "Being in the military prepared me for life," he said. "I never quit" (*Truce*, p. 60).

"Were you ever afraid?" I asked several veterans, including Winston, an astronaut with NASA.

"Afraid?" he laughed. "We were trained so well we just focused on doing our job." Winston served as a Navy pilot and later completed three spacewalks during his career as an astronaut. His lifelong interest in flying, whether in a Navy helicopter or on the space shuttle *Columbia*, began in third grade, when he gave a book report on Project Mercury, NASA's first manned space program (*Crescent Moon*, pp. 32, 33).

Whether the veterans had experienced real fear or homesickness, few ever expressed it. Instead, what most conveyed was an extraordinary sense of patriotism. Many said they originally joined the military to "make a difference." One need look no further than the scores of veterans proudly flying American flags from their porches and mailboxes, wearing T-shirts and hats with emblems of eagles or fighter planes, or hosting barbecues to raise money to maintain the grave sites of fallen comrades. Even more than a brotherhood, service in the military for many becomes a way of life, a rarified code of conduct. George, a chair maker from New Hampshire, summed it up best when he proudly told me, "Once a Marine, always a Marine. Even my wife salutes!" (*Cloister*, p. 73).

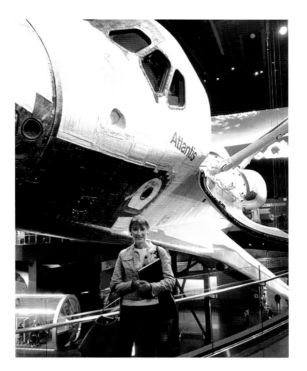

Getting behind the scenes at NASA was one of the highlights of my travels.

For some veterans, transitioning back into society was a wrenching and unforeseen challenge, as the world they returned to was vastly different from the one they left behind. Being away from home for several years, or longer, meant that the soldiers had missed everyday life with their families and neighbors, and the daily growth and changes that come with time. Children's birthdays were celebrated without them, and family holiday dinners were missed. Old neighborhoods, favorite burger joints, and former lovers had disappeared or moved on without them, making them feel alone. Single friends that they had always been able to count on for an impromptu beer now had family responsibilities and spent Saturday nights at home. More than one veteran told me he came home to an empty house with a note from his wife letting him know she had left him for someone else. And still others came home to a previously promised job only to find it had been given to an employee with more current work skills.

The repercussions of war have driven many of our veterans to a life on the streets and in the woods. Homelessness is the unspoken failure of our democracy, with the U.S. Department of Housing and Urban Development's 2017 Annual Homeless Assessment Report indicating that an estimated forty thousand veterans are homeless on any given night. Limited access to health care, a shortage of affordable housing, the lingering effects of PTSD, and substance abuse are all contributing factors. The lack of family and support networks can compound the problem. Suicide is far too common.

Many homeless veterans live together in small, makeshift communities away from the everyday movements of the public. Few outsiders are allowed access, even if they are offering much needed supplies such as food or blankets. I learned of one such "camp" near Carmel, California. I hired a homeless veteran and his girlfriend who were familiar

with the woods to guide me to it. We parked our cars by the side of the road, and I followed them, with my sketchbook, camera, and a bag of dogfood, up an unmarked trail, as hidden and as furtive as deer tracks. The narrow path gave way to a rocky incline as we hiked deep into the forest. At the top of the ascent was a stand of majestic pines that reached to the sky like the columns of a cathedral. Shafts of light filtered down, dappling an encampment of drooping tents and piles of discarded plastic jugs and water bottles. This was where I met Dennis, a sixtyish veteran with his dog, a constant companion.

Dennis's story isn't much different from those of other homeless veterans. A series of unfortunate setbacks left him without income for a time and without the means to pay rent. Today he prefers the sanctuary of the woods. Dennis still has hopes of a more stable future, going fishing now and then, and settling down one day with his lady friend. As Dennis and the other men demonstrated to me that day, being homeless does not mean being dreamless (*Bunker*, p. 25).

Previously homeless, Joanie managed to work her way back to her lifelong dream of living in her own home. Born in Honduras and a single mother of two, Joanie saw the Army as an opportunity to get an education. Deployed to Afghanistan as a sergeant, she was given a job of working in construction. Six months after she returned home from the military, the young woman was homeless with two teenage sons and living in a Catholic Charities shelter in Houston. From her window she saw new homes under construction a block away, and she walked over to apply for a job. After working several months, she then had a steady income, and her boys were doing well in school. The day I met her she had just gotten her very own apartment. She told me proudly, "This is just the start. Someday I am going to build my own house" (*Counterbalance*, p. 101).

Tynaya, another single mother of two, grew up in foster care. She was homeless at one time and is now working at the detention center and living in an apartment with her two sons near Charleston, South Carolina (*Family*, p. 95). For many veterans reentering society is a lifelong process. Without the structure of the military, many of them have developed a strong brotherhood that

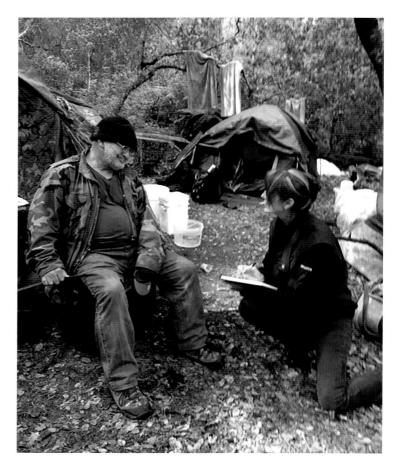

Some homeless camps are very hidden and difficult to get to. I was fortunate to gain the trust of several homeless veterans who brought me to this site in the woods near Carmel, California.

can be found in the VFW halls and American Legion Posts across the country. Younger veterans I spoke to tend to gravitate toward groups that encourage activities such as running or volunteering. Veterans of the wars in Iraq and Afghanistan have joined organizations that allow them to stay active, continuing to serve their country and interacting with civilians who help reintegrate them into society. Learning to deal with stress from deployments and anxiety about the future is ongoing, as is the pressure of keeping up with relevant job skills and finding meaningful employment.

Many vets told me it was the camaraderie they loved the best about their time in the military. Several still maintain contact with the soldiers with whom they served decades ago. "We were brothers," a Missouri Army vet, who had been in Korea, told me. "When you know someone has your back no matter what, you count on it. You don't find that outside the military. You're on your own."

Some veterans take a more pragmatic if not humorous view of learning to adapt, like Ed, a North Carolinian who served in both the Marines and the Army. "Yeah," he said wryly, "I had sixteen great years in the military, and one really bad day." After a rocket-propelled grenade had blown off one of his legs, Ed spent months in rehab adjusting to different prosthetics and learning to walk again. Now that doctors have successfully fitted him with a shiny, high-tech leg, Ed moves about with a nearly normal gait, reserving his powerful sleekness and speed for competitive bicycling (*Archangel*, p. 81).

Most of the fifty watercolors in this series were painted in the studio I had in South Carolina for twenty-seven years. Situated alongside a tidal marsh, the house and studio were close to the Bohicket Creek, a pristine waterway that winds its way to the North Edisto and eventually to the Atlantic Ocean. The wood ducks gliding by on the creek kept me company by day, and at night, under a full moon, I could hear the owls and, in the far distance, the ocean.

The studio was in the room over the garage, with enough space and light to create the largest of the paintings. Access to the studio was through the kitchen, which meant that a cup of tea was always nearby. Leading up to the workspace was a short flight of seven steps. Shortly after moving into the house, I painted the studio a light gray and added a word in Italian to the riser of each step: *Perseveranza, Corragio, Ispirazione, Fantasia, Forza, Visione,* and *Fede.* Translated into English each word represents a necessary component of what I need in order to accomplish my task each day: perseverance, courage, inspiration, imagination, strength, vision, and faith. These seven incantations are my daily guide to constantly maneuvering new terrain, to keeping strong, and to staying on course. These are words I would hear over and over again, spoken by the veterans.

In the studio my tools for working are minimal. Paintbrushes, pencils, water jar, watercolor paints, paper towels, and a mixing tray are my most constant devices for painting. Paper is stapled to a board, placed on an easel, and positioned so that the light comes over my left shoulder. On cloudy days the skylights in my studio are augmented with lighting similar to that which photographers use to illuminate their subjects softly.

After referring to all my resource photographs, I do a thumbnail sketch. Generally, while no larger than a playing card, a small, quick pencil drawing is the seed of an idea

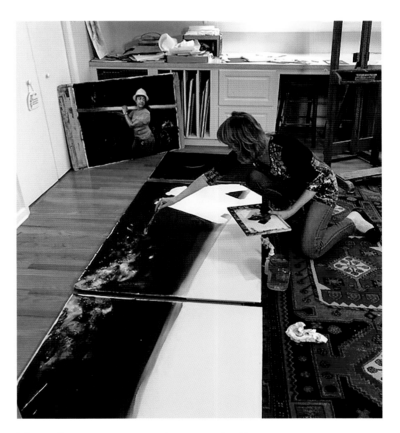

Most of my paintings are done upright. However, sometimes it is necessary to paint flat in order to have the washes behave in a certain way.

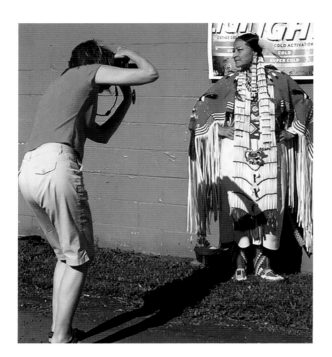

Photographs help me remember important details as well as how lighting can make a difference with a subject.

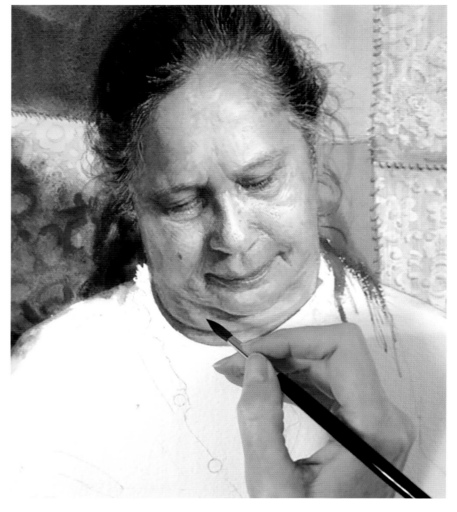

The pencil lines act as a general guide. Once the larger washes are established, I can move on to painting the small details.

and composition. Although lacking in detail, these brief annotations are vague enough to carry the dream of many possibilities. I may need to make several sketches exploring different elements and formats before a strong concept begins to take shape. Over the years I have discovered that it isn't what is put into a painting that makes it powerful, as much as it is what is eliminated. To give an idea of the evolution of a painting, each one depicted in this book is presented with the initial thumbnail sketch I did for it.

The final painting is begun in pencil by drawing the larger shapes on the paper. Later, many of the lines can be erased, but during the painting process they are helpful

as guides. The initial brush stokes are always the biggest and the fastest, using broad movements timed for the end result. Timing is critical in watercolor given that the quality of edges and color mixtures are predetermined by the speed with which they were executed. It can be an exhilarating and sometimes frustrating business, resulting in some cases in totally scrapping a nearly completed painting and starting over. As the accomplished artist John Singer Sargent quipped about watercolor, the medium can accurately be described as "making the best of an emergency." For me, starting a painting over is never an issue, since I look at mistakes as lessons and part of the process.

Over the length of my career, as well as during this project, I have had to start many paintings over. As in life, each new attempt has reinforced in me the need for faith and perseverance. Perhaps the most important thing I have learned during the course of this project is that part of an artist's job is to be a healer. It is my hope that these fifty watercolor portraits give rise to a greater sense of gratitude for our military, as well as to inspire people to reach for what is possible. Art can elevate those among us who have been overlooked, and turn the unseen into light.

After seven years my yellowed and curled map of the United States is finally finished and completely colored in red. It is an irregular crimson shape charting one artist's zig-zagged adventure of discovery and wonder. I met the goal of visiting every state and painting fifty watercolors of veterans representing the notable diversity of our country. Mine was an imagined grand portrait that ended up being a love letter to my country as well as to our veterans and their families.

Like most artists I am frequently asked, "How long did the painting take?" It is a difficult question to answer. Was the watercolor knocked off over the course of a martini, or was it the result of months of near insanity, working alone in an attic while minus an ear? Trying to quantify how long any work might have taken to create diminishes all that was sacrificed and required for the artist to get to this level of accomplishment. How do you add up all the years of study and practice? How do you count the number of paintings that failed and had to be torn up and started over? Or do you count just the ones that succeeded?

The answer to that question reminds me of a conversation I had with a ninety-two-year-old veteran from Greenville, South Carolina. When I met Gus, he was standing near the entrance of the VFW, wearing a navy-blue jacket that was shiny and rounded at the elbows. The hems of the senior's khaki trousers puddled around his wide, brown shoes. An oversized baseball cap with the stitching "WORLD WAR II VETERAN" covered the tops of his ears. On his left lapel was fastened a tiny American flag.

"How long did you serve?" I asked, gesturing toward the pin.

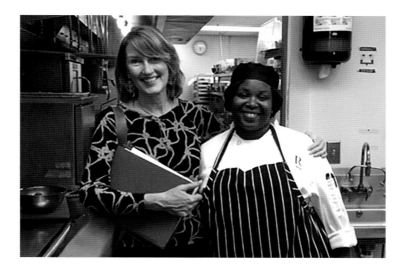

During the course of this project, I met many extraordinary people who were striving to achieve their dreams, including this chef from Alabama.

Gus crooked his head to the side and squinted up at me under the brim of his hat. His eyes were the color of the Pacific, the wide, blue expanse he had likely crossed several times during the war. The hands that once aimed fury's cold metal now gripped a cane as he straightened to his full height.

"All my life," he answered, squaring his shoulders.

Someday soon Gus's story will be a single white page included among the many on the hillside at Arlington National Cemetery. In time his great-great-grandchildren will celebrate Memorial Day grilling hot dogs while wearing silly red, white, and blue hats, and he may be forgotten. Regardless, three times a week the ninety-two-year-old widower comes to stand at the door of the VFW. He is there to greet visitors and, if they ask, tell them what World War II was like for an eighteen-year-old boy from a small mill town in South Carolina. Given in three short words, Gus's answer to my question about his service was the ultimate call of duty, all coming down to the significance of a tiny pin. Whether it is how long it takes to pass freedom on to the next generation or to make a painting, it is the simple measure of one's dedication and commitment.

All my life.

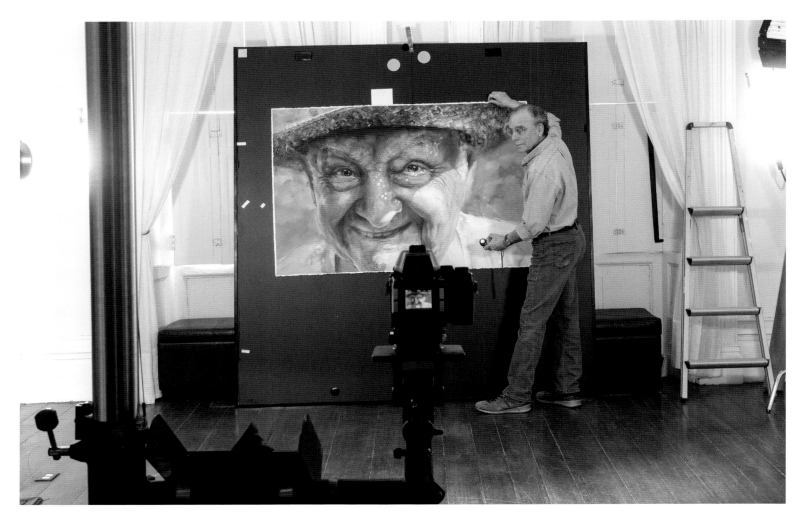

When each painting is completed I have it professionally photographed for my records. Jack Alterman is shown photographing a finished watercolor in his studio.

A Commander in Chief's Tribute to Our Veterans
President George W. Bush

Arlington National Cemetery
Arlington, Virginia
Excerpt, Veterans Day, 2004

These are the hidden heroes of a peaceful nation: our colleagues and friends, neighbors and family members who answered the call and returned to live in the land they defended.

All who have served in this cause are liberators in the best tradition of America. Their actions have made our nation safer in a world full of new dangers. Their actions have also upheld the ideals of America's founding, which defines us still. Our nation values freedom — not just for ourselves, but for all. And because Americans are willing to serve and sacrifice for this cause, our nation remains the greatest force for good among all the nations on Earth.

Our men and women in the military have superb training and the best equipment and able commanders. And they have another great advantage — they have the example of American veterans who came before. From the very day George Washington took command, the uniform of the United States has always stood for courage and decency and shining hope in a world of darkness. And all who have worn that uniform have won the thanks of the American people.

Today, we're thinking of our fellow Americans last seen on duty, whose fate is still undetermined. We will not rest until we have made the fullest possible accounting for every life.

Today we also recall the men and women who did not live to be called "veterans," many of whom rest in these hills. Our veterans remember the faces and voices of fallen comrades. The families of the lost carry a burden of grief that time will lighten, but never lift. Our whole nation honors every patriot who placed duty and country before their own lives. They gave us every day that we live in freedom. The security of America depends on our active leadership in the world to oppose emerging threats and to spread freedom that leads to the peace we all want. And our leadership ultimately depends on the commitment and character of the Armed Forces.

America has needed these qualities in every generation, and every generation has stepped forward to provide them. What veterans have given our country is beyond our power to fully repay, yet, today we recognize our debt to their honor. And on this national holiday, our hearts are filled with respect and gratitude for the veterans of the United States of America.

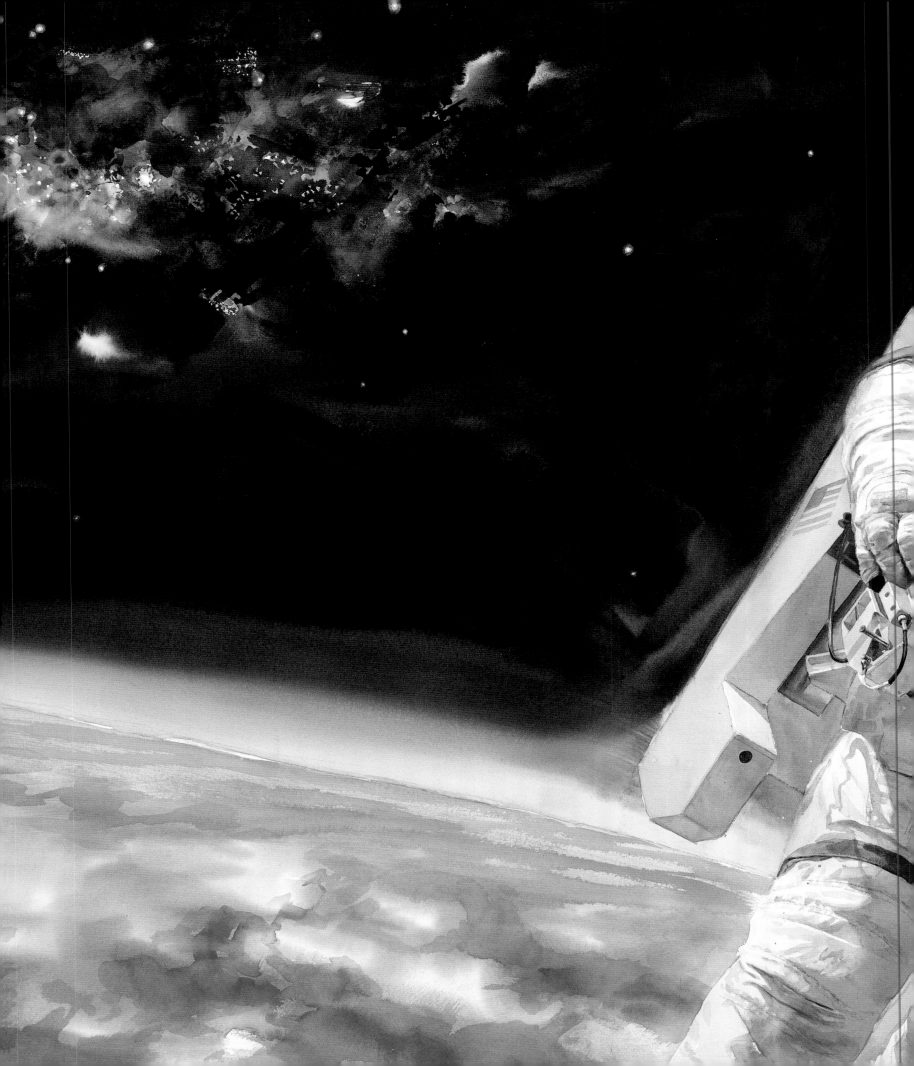

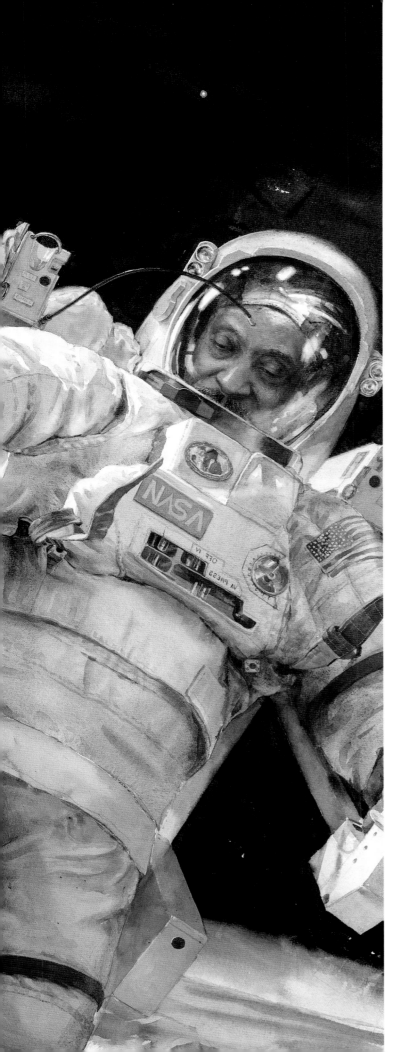

The Paintings

Bouillabaisse

Bouillabaisse, chef
Watercolor on paper, 34.375 × 29 inches, 2017
Wendy, Birmingham, Alabama
Army Private First Class, 1996–99

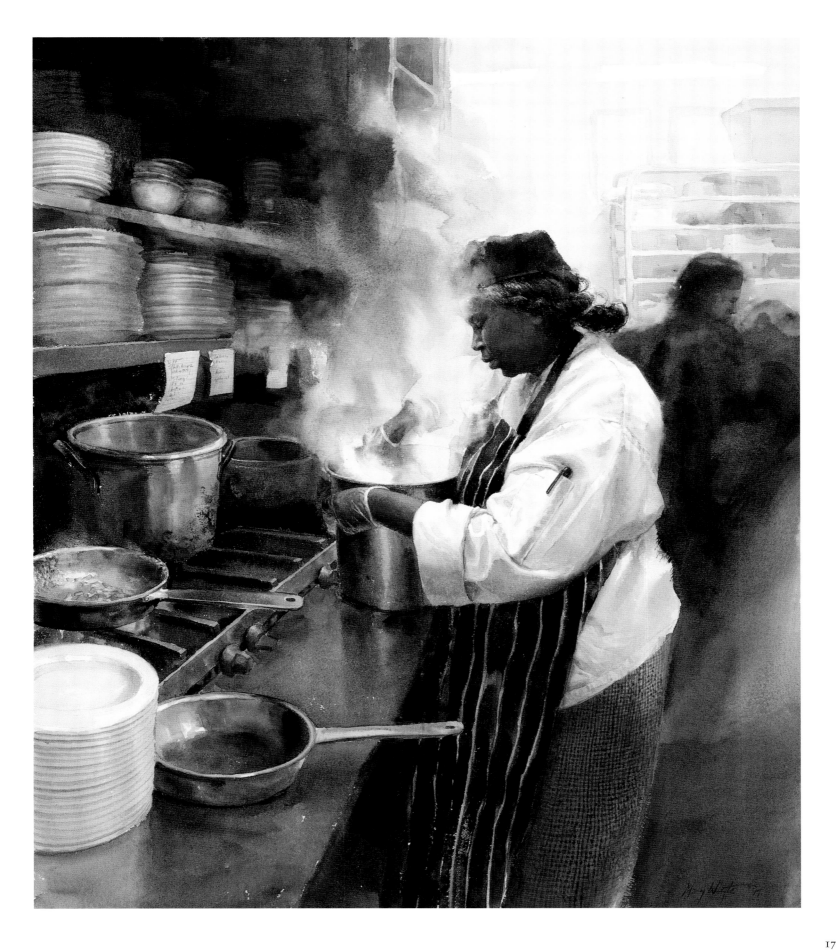

Special Delivery, postmaster
Watercolor on paper, 27.75 × 40.25 inches, 2015
Adriane, Skagway, Alaska
Air Force E-4, 1989–93

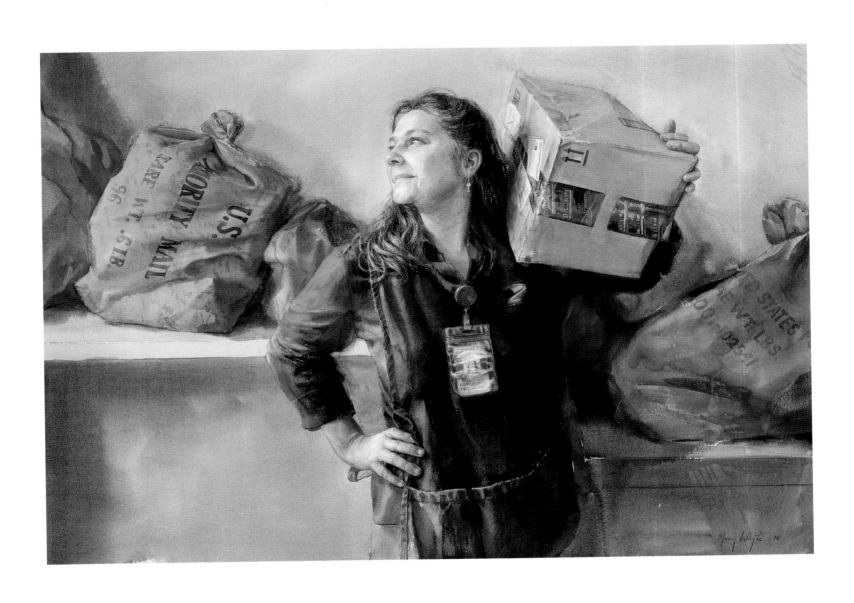

Tattoo

Tattoo, tattoo artist
Watercolor on paper, 40.5 × 28 inches, 2012
Scott, Litchfield Park, Scottsdale, Arizona
Navy GM3, 1994–98

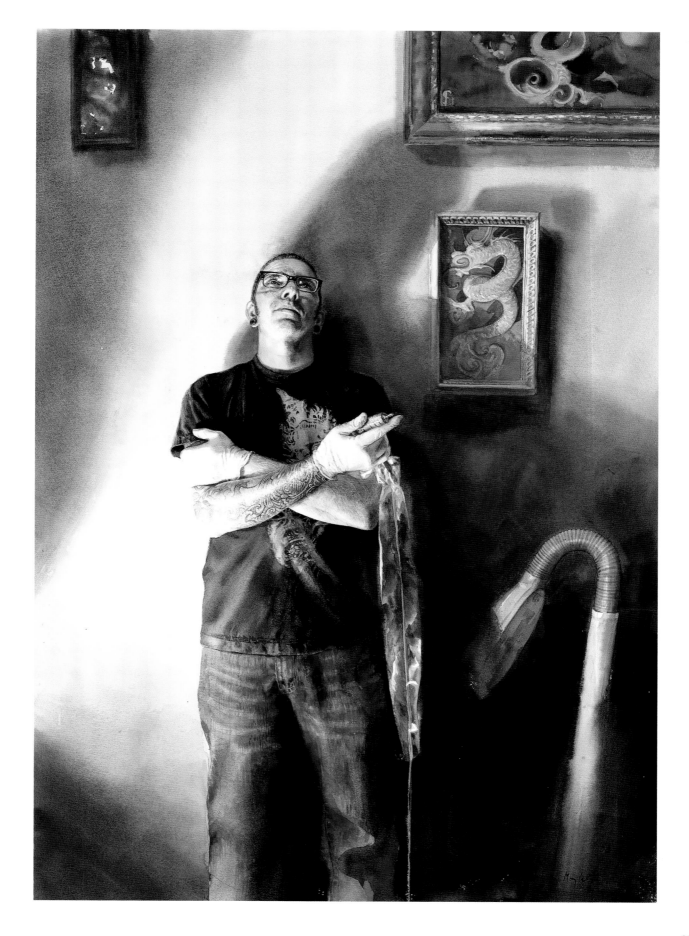

Overflow, garbage collector
Watercolor on paper, 40.25 × 26 inches, 2017
C. H., Harrison, Arkansas
Marines Private, 1971–73

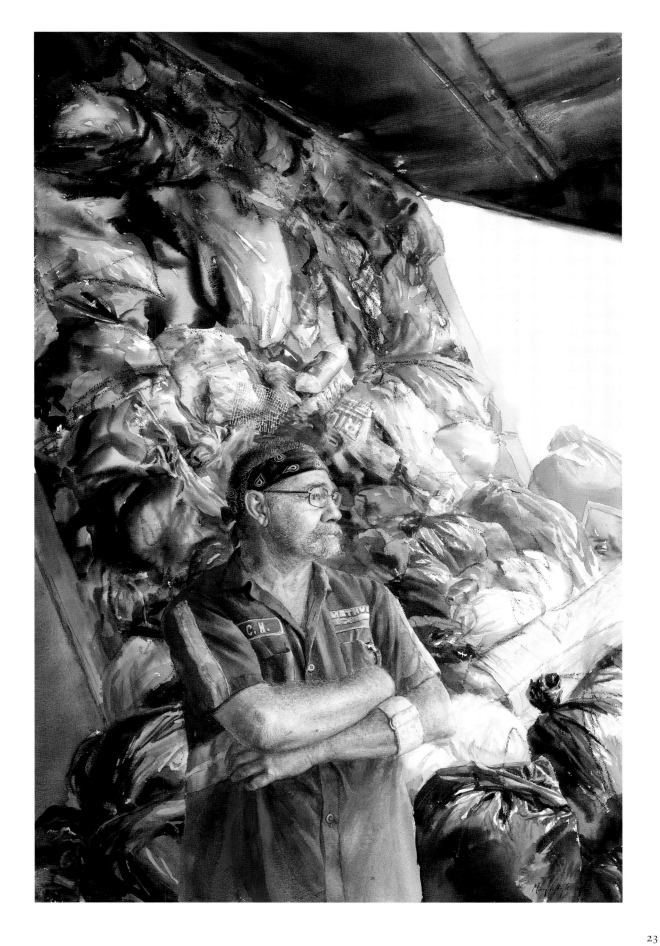

Bunker, homeless
Watercolor on paper, 20.25 × 28.25 inches, 2017
Dennis, Seaside, California
Army E-4, 1972–75

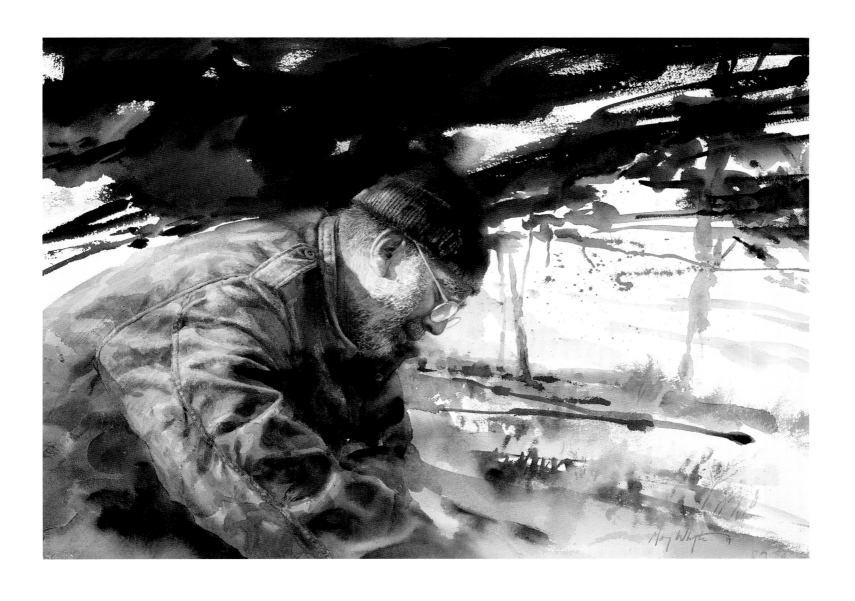

Creation, artist
Watercolor on paper, 33 × 29.50 inches, 2017
Karl, Fruita, Colorado
Army Private, 1951–53

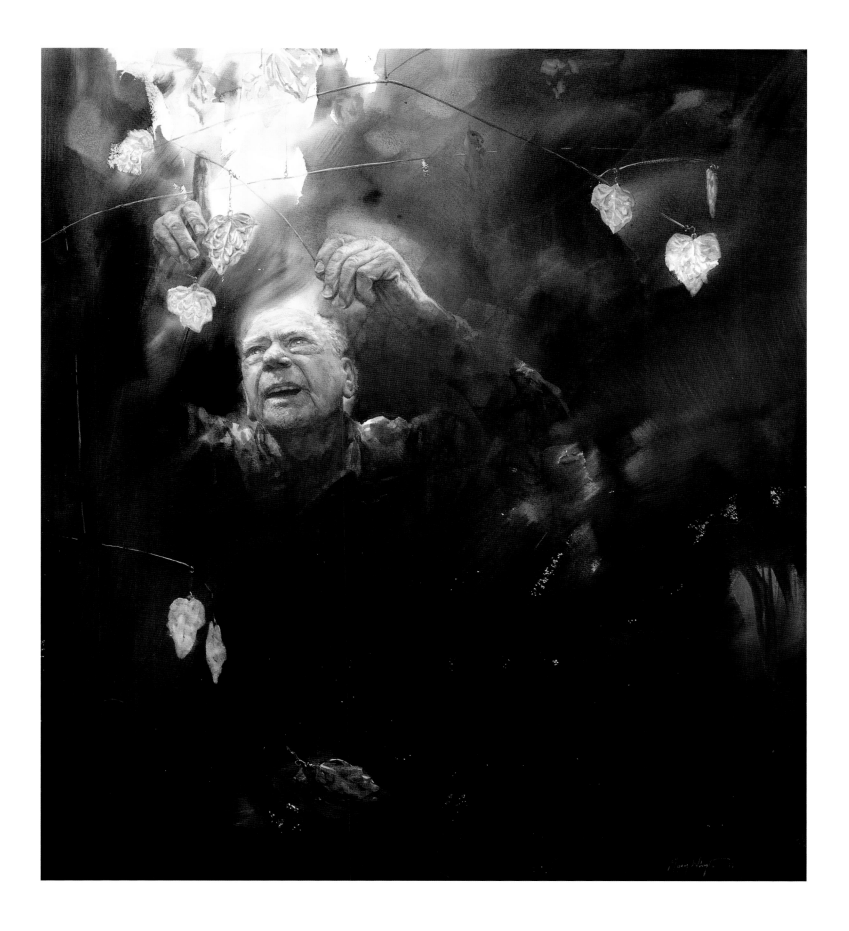

"Homeland"

Homeland, police officer
Watercolor on paper, 27.5 × 40 inches, 2014
Renee, Waterbury, Connecticut
Marines Lance Corporal E-3, 1987–91

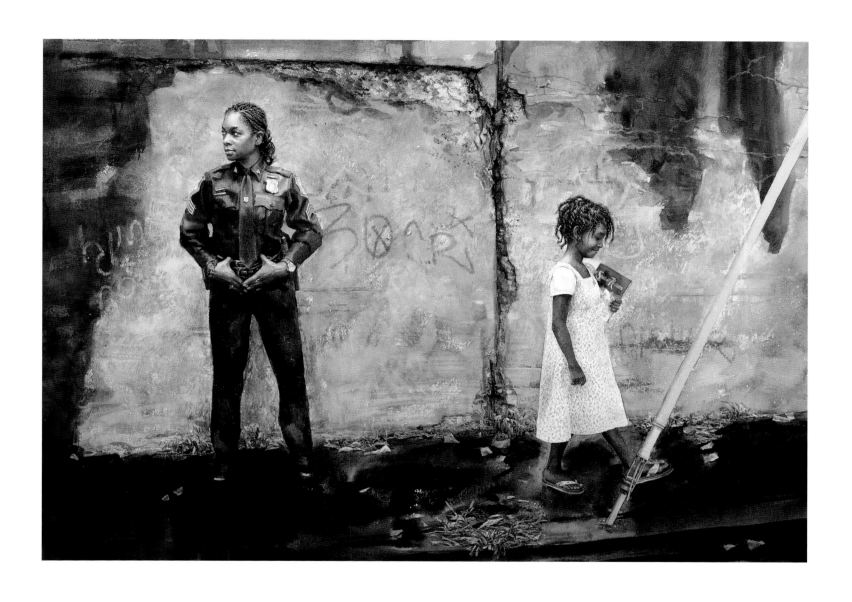

Spiral, mayor
Watercolor on paper, 28.5 × 37 inches, 2016
Anthony, Harrington Delaware
Navy Hull Tech E-4, 1979–84

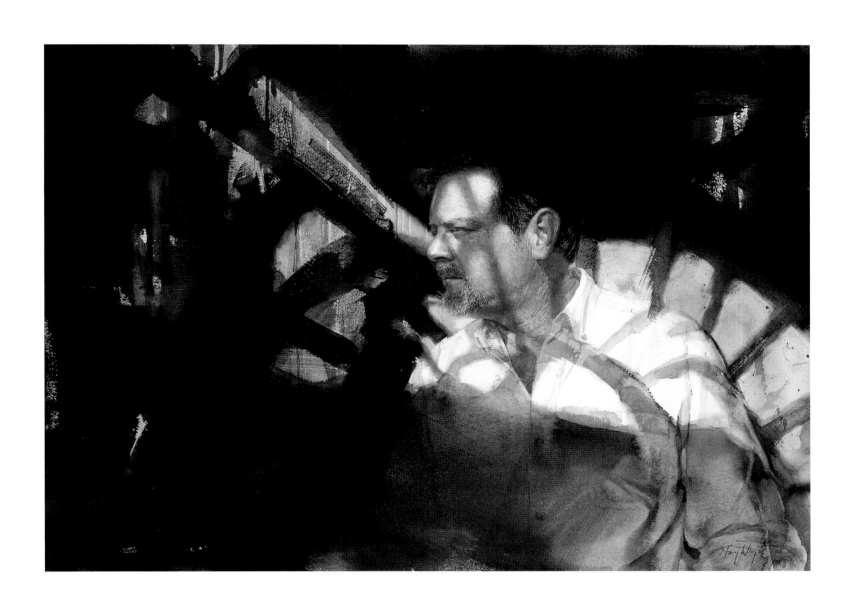

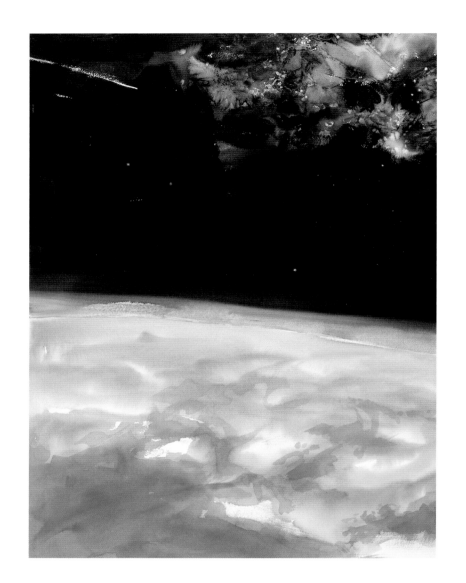

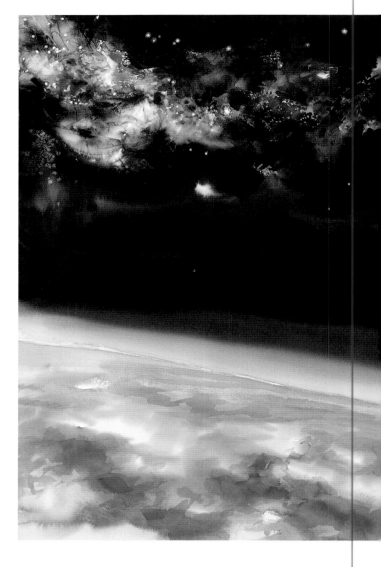

Crescent Moon, astronaut
Watercolor on paper
39.625 × 29.375; 39.625 × 59.375;
39.625 × 29.375 inches, 2018
Winston, Rockledge, Florida
Navy Captain, 1973–99

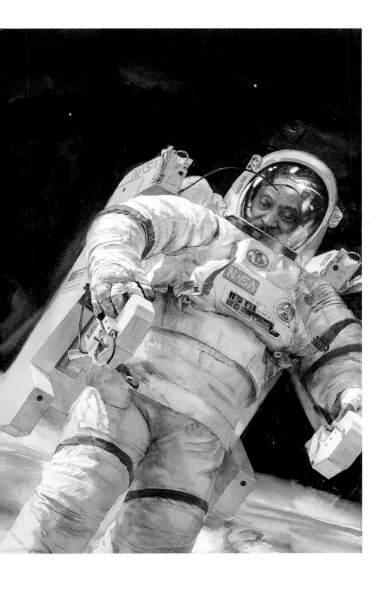

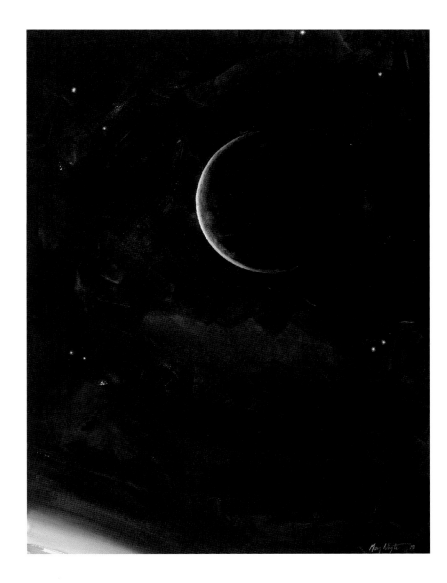

Glory, great-grandmother
Watercolor on paper, 28.5 × 20 inches, 2015
Amelia, Savannah, Georgia
Air Force Sergeant WAAC, 1943–45

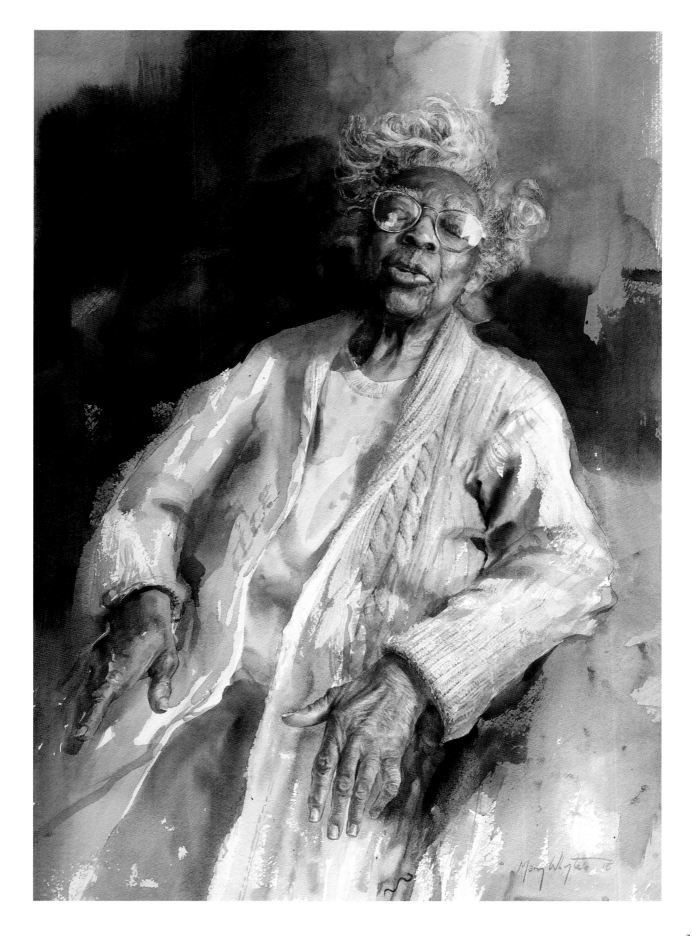

Driftwood, retired homebuilder
Watercolor on paper, 27.75 × 40.75 inches, 2015
Hiroshi, Kula, Hawaii
Army Warrant Officer, 1943–45

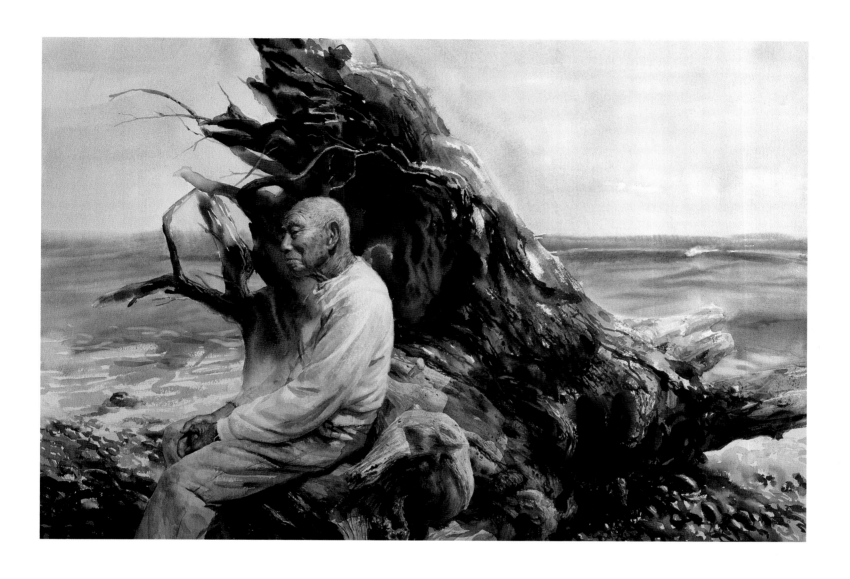

Reunion, falconer
Watercolor on paper, 40.75 × 28.50 inches, 2015
Kenneth, Moyie Springs, Idaho
Army E-5 Specialist, 1959–62

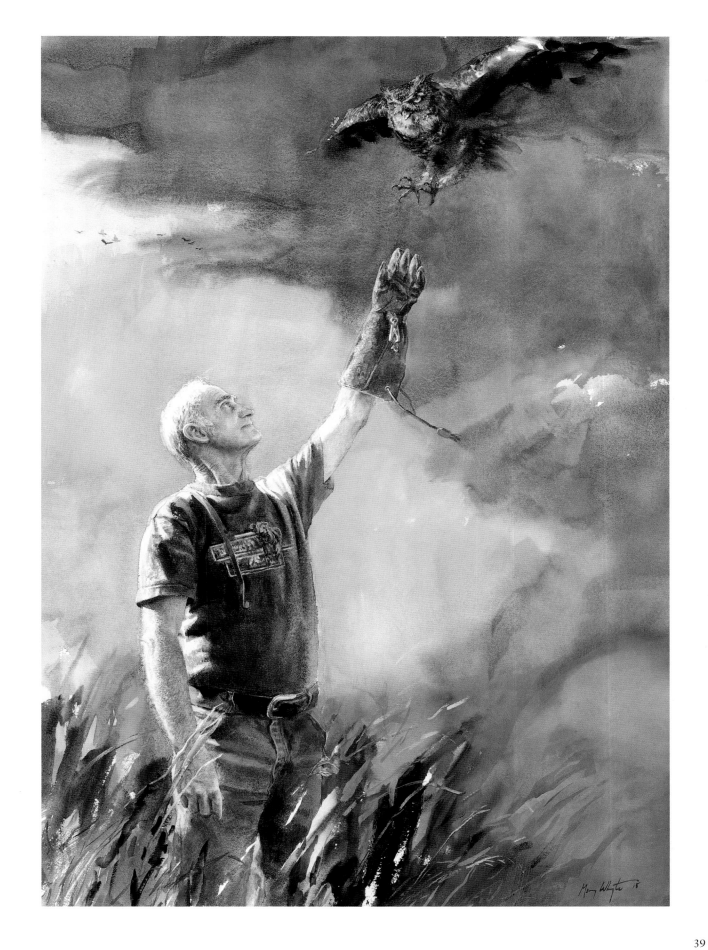

Face, circus clown
Watercolor on paper, 27.75 × 23 inches, 2012
Sean, Chicago, Illinois
Marines Corporal E-4, 1990–94

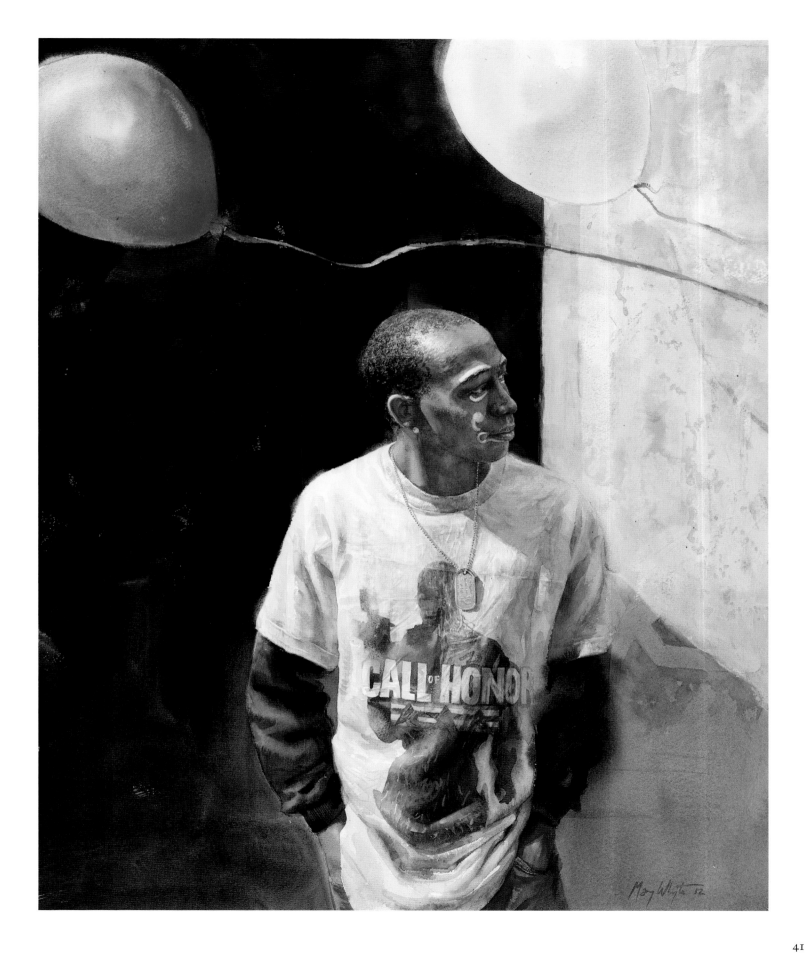

Swim, zoo keeper
Watercolor on paper, 39.25 × 58.50 inches, 2015
Sarah, Warsaw, Indiana
National Guard Sergeant E-5, 2010–2014

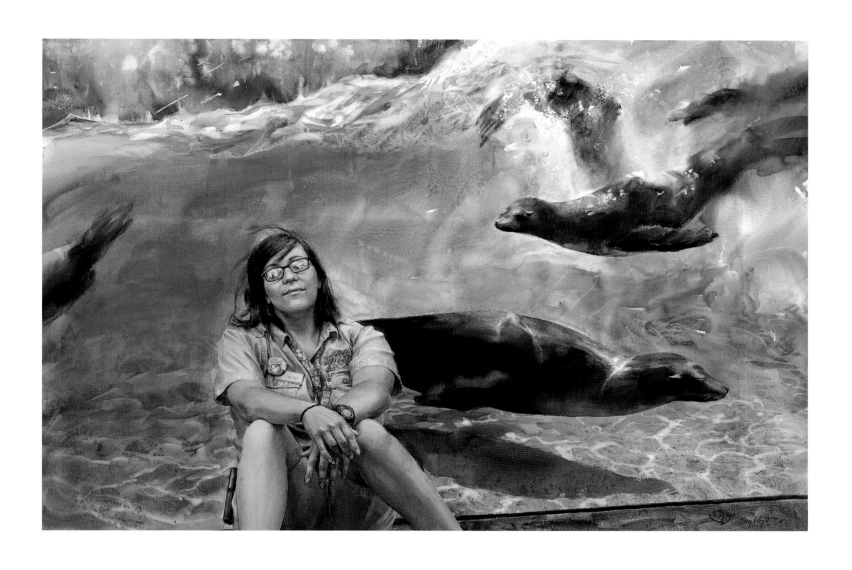

Eternity, corn farmer
Watercolor on paper, 27.5 × 40.25 inches, 2014
Edward, Woodbine, Iowa
Navy Fireman First Class, 1945–46

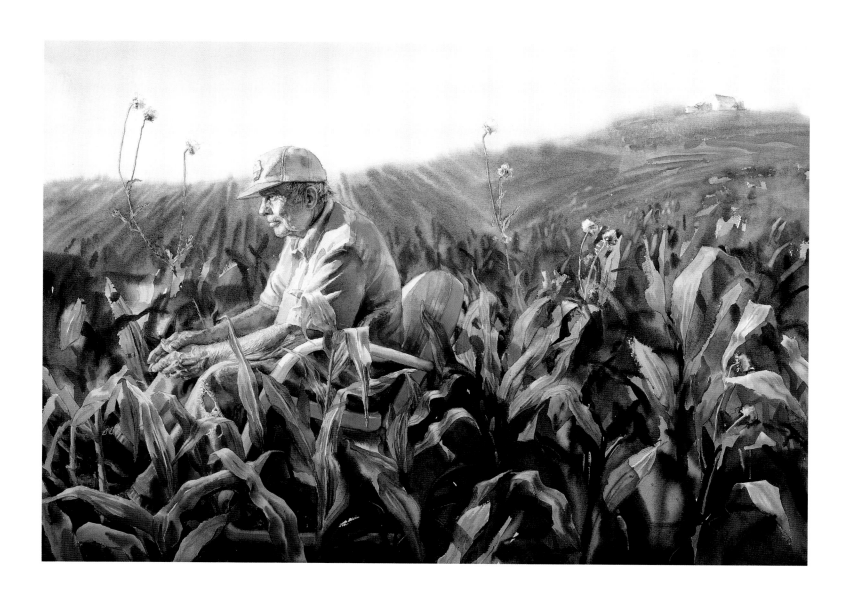

Forty Hours /overtime

Overtime, welder
Watercolor on paper, 61.75 × 47.5 inches, 2014
Dwain, Wathena, Kansas
Navy E-5, 1984–90

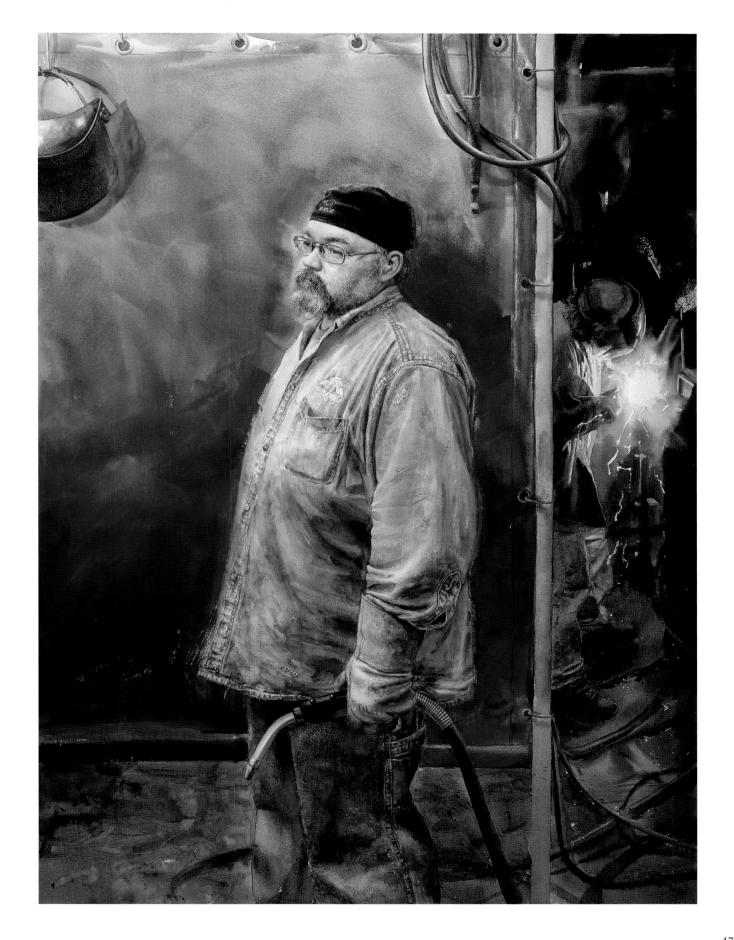

Spill out Backside
Dark Horse

Dark Horse, stable hand
Watercolor on paper, 30.5 × 22.25 inches, 2014
Robert, Louisville, Kentucky
Army E-4, 1984–89

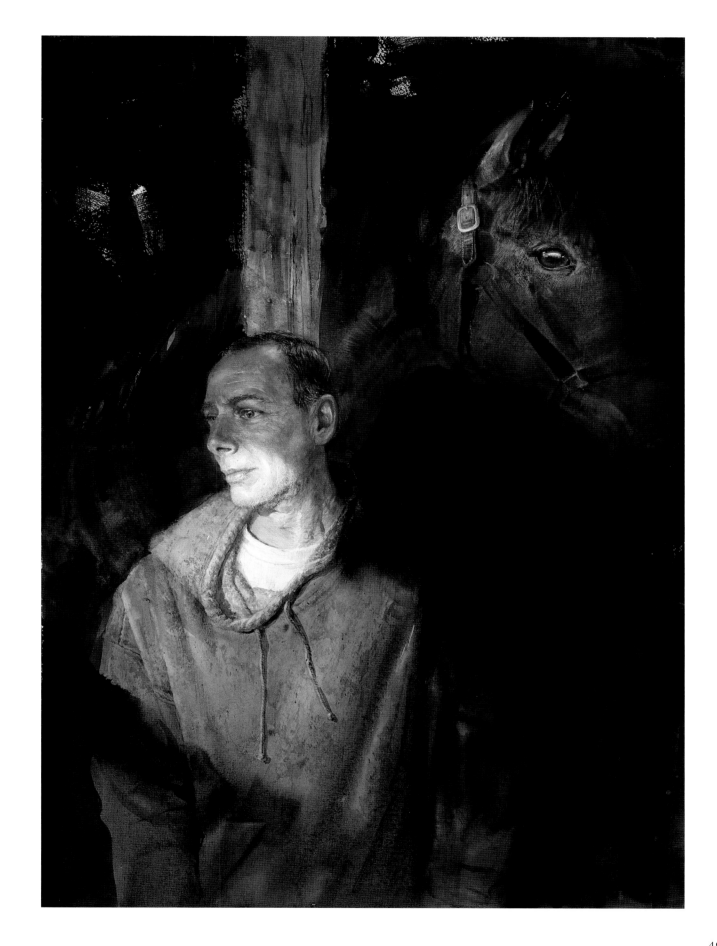

Encore, musicians
Watercolor on paper, 28.5 × 36.25 inches, 2016
Roselyn, New Orleans, Louisiana
Air Force Airman 3rd, 1957–60
David, New Orleans, Louisiana
Air Force Airman 2nd, 1956–60

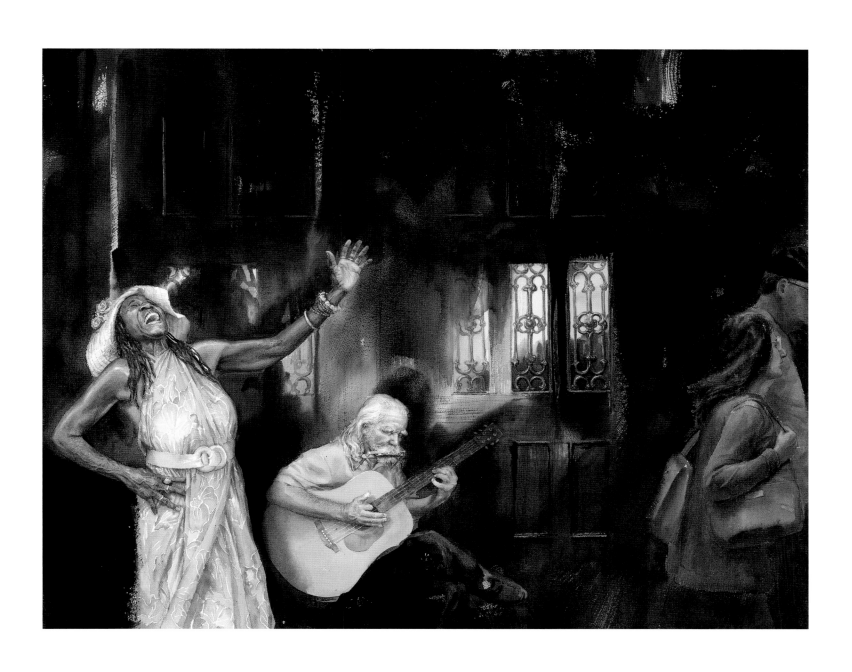

Seaward / Vigil / ME

Vigil, marine patrol officer
Watercolor on paper, 29 × 41 inches, 2017
Jodi, Deer Isle, Maine
Coast Guard BM1 Petty Officer, 1982–91
Reserves, 1991–2004

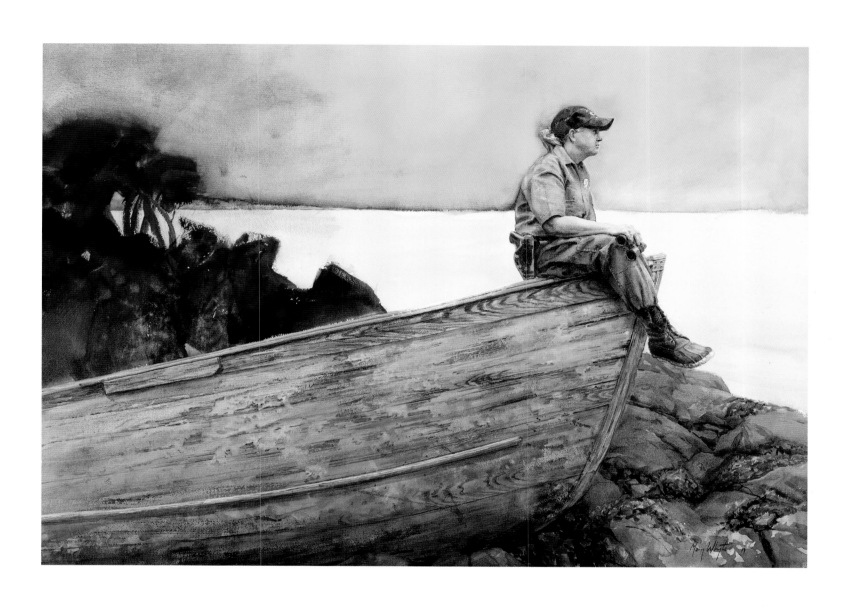

Lunch Hour, food truck operator
Watercolor on paper, 22.5 × 29 inches, 2015
Michael, Hyattsville, Maryland
Army Sergeant, 1983–2007

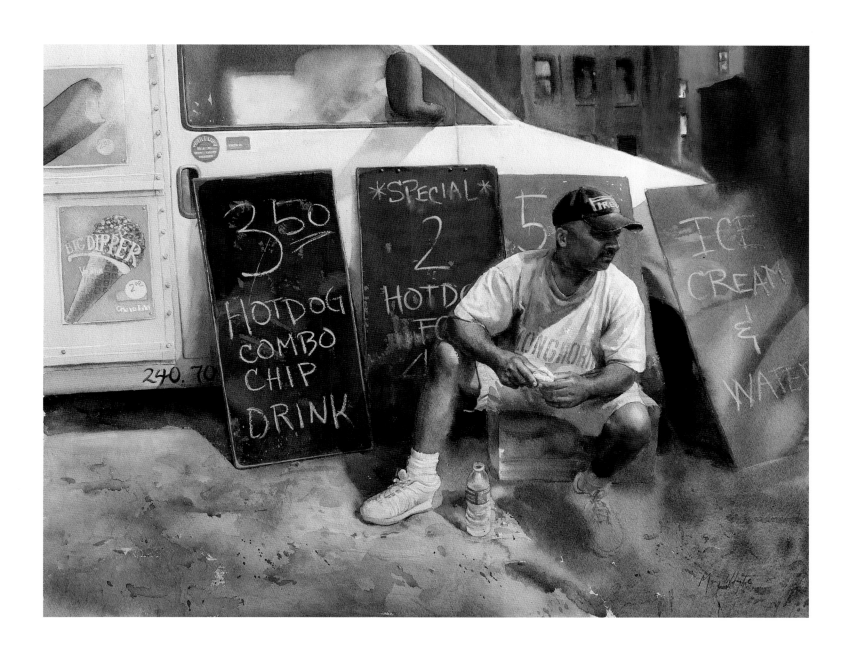

Full Tilt, motorcycle racer and mechanic
Watercolor on paper, 29.375 × 29.75 inches, 2017
Rick, Marlboro, Massachusetts
Navy E-5 GM2, 1970–74

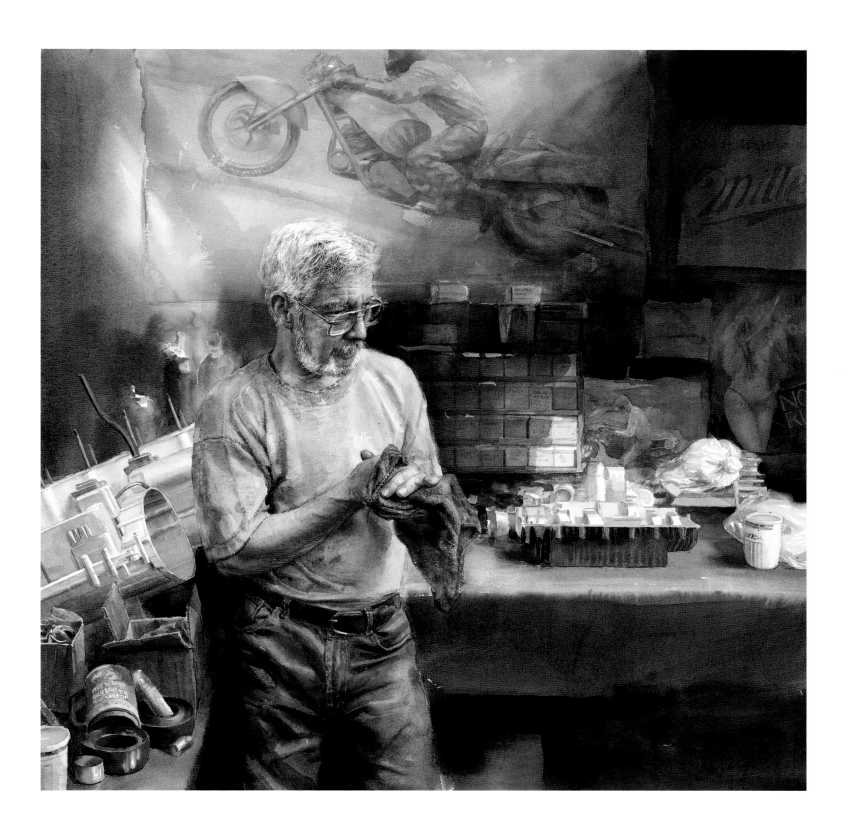

Window, window washer
Watercolor on paper, 38.5 × 28.25 inches, 2016
Christian, Oak Park, Michigan
Army Private First Class, 2007–2011

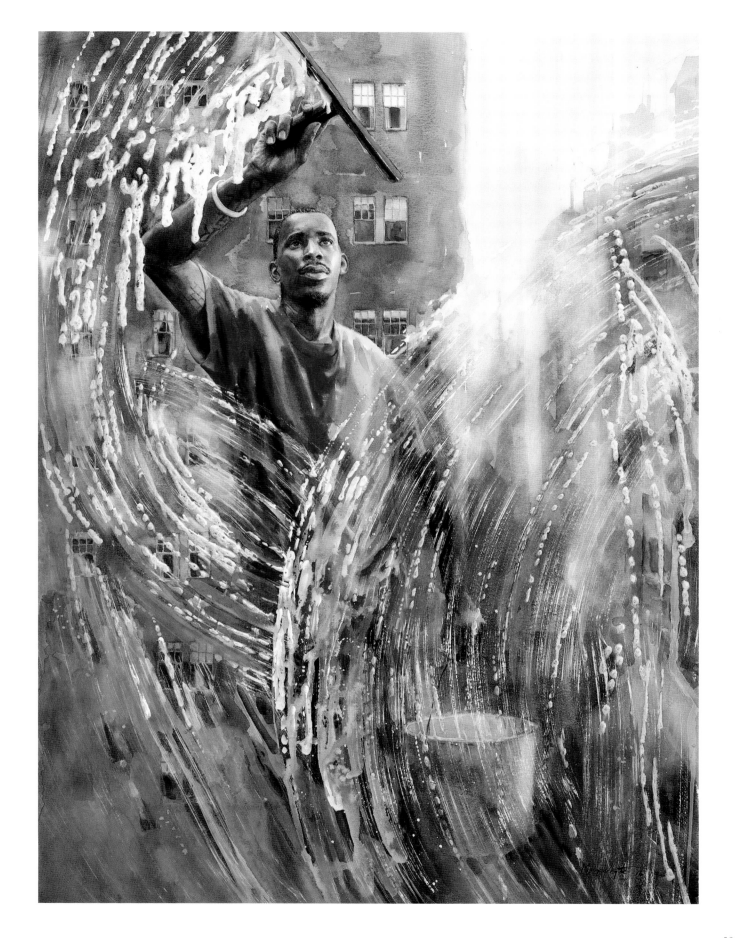

Truce, taxidermist
Watercolor on paper, 36.5 × 37 inches, 2016
Dan, Williams, Minnesota
Marines Corporal, 1968–69

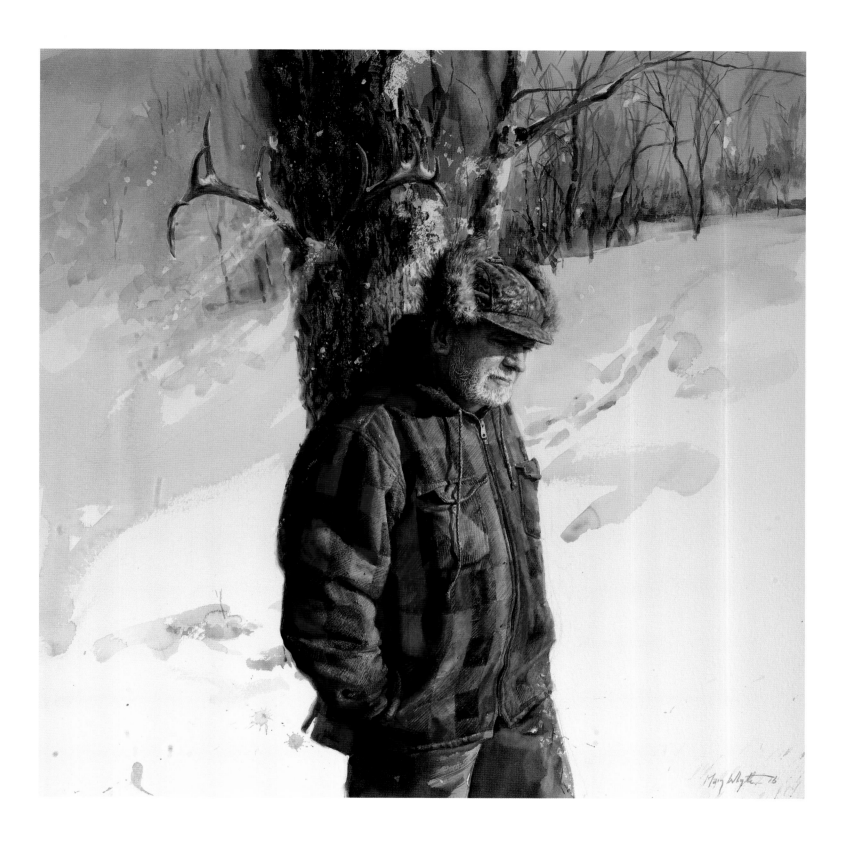

Aloft, roofer
Watercolor on paper, 35.5 × 27.5 inches, 2017
Martin, Meridian, Mississippi
Marines Corporal, 1956–59

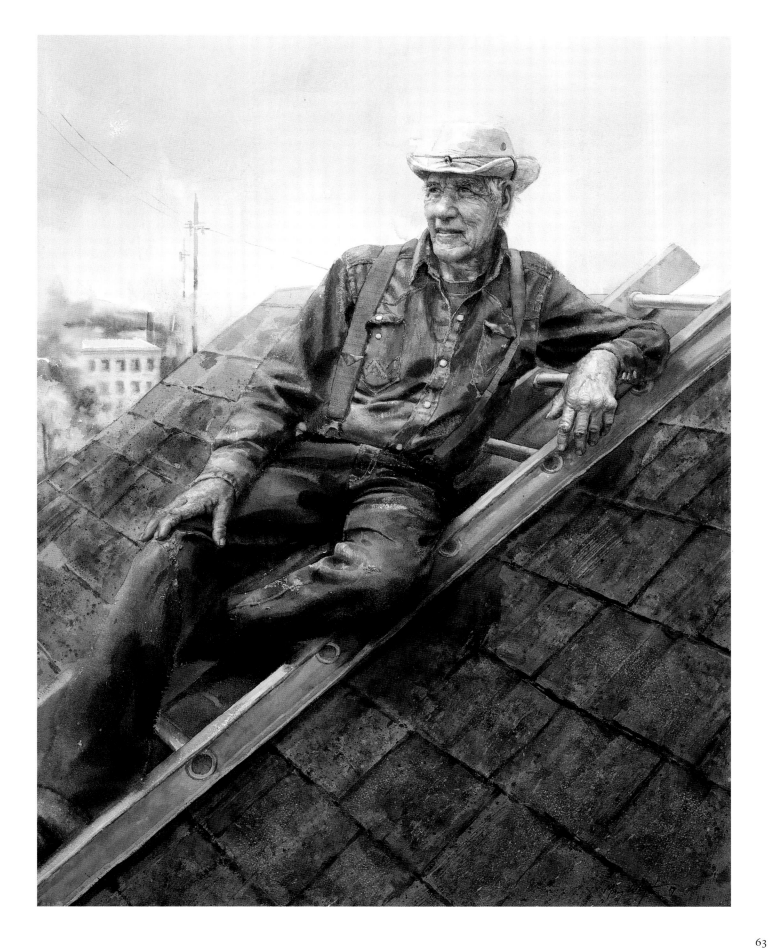

Holsteins, dairy farmer
Watercolor on paper, 28.25 × 40.75 inches, 2014
Darrell, Norwood, Missouri
Army E-4, 1968–71

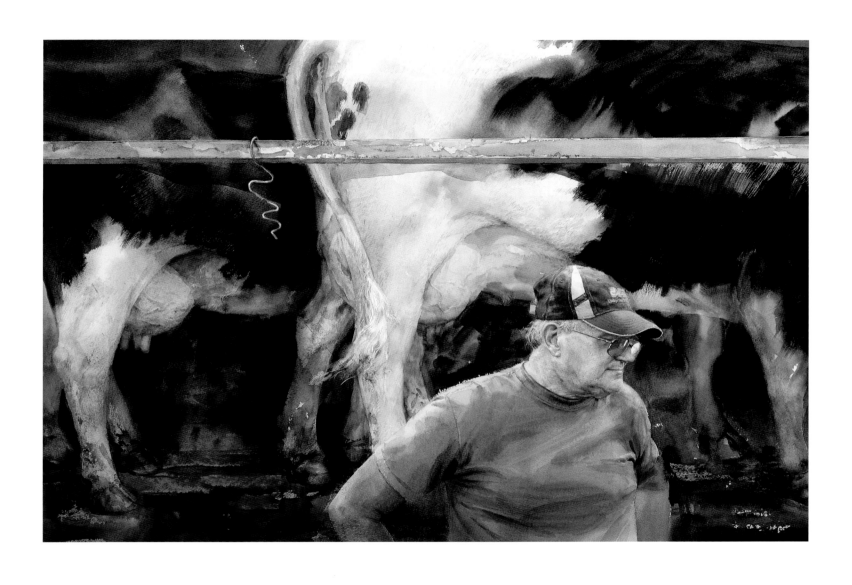

Roller, logger
Watercolor on paper, 28.25 × 28.50 inches, 2015
Rodney, Columbia Falls, Montana
Marines Sergeant E-5, 1975–79

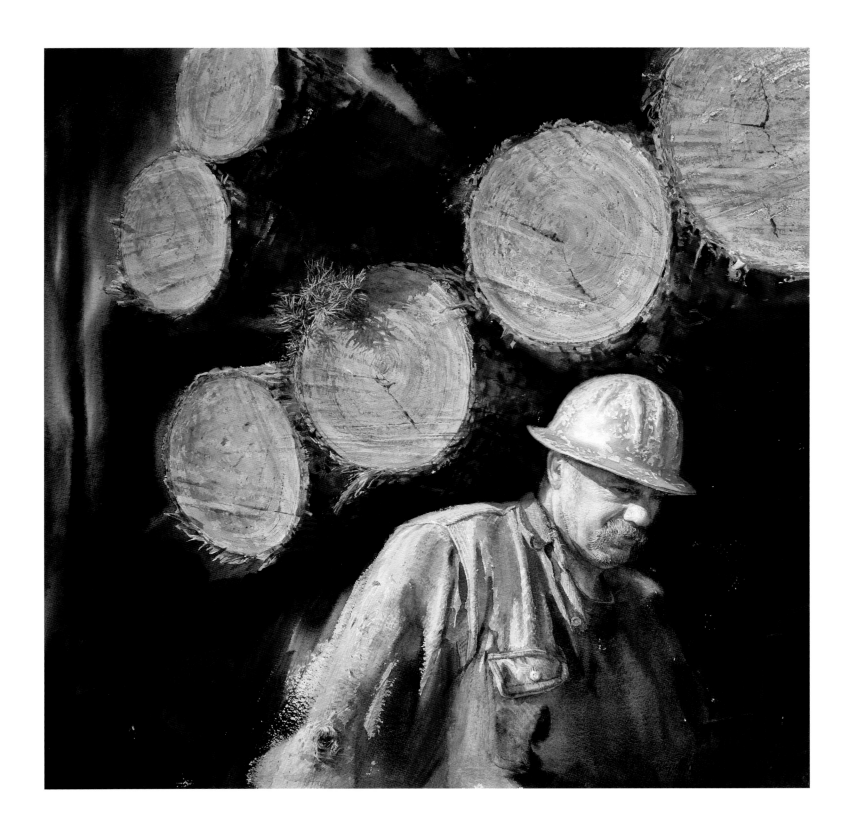

Armistice, boxing trainer
Watercolor on paper, 29 × 38 inches, 2014
Taija, Omaha, Nebraska
Air Force Airman First Class, 2006–2010

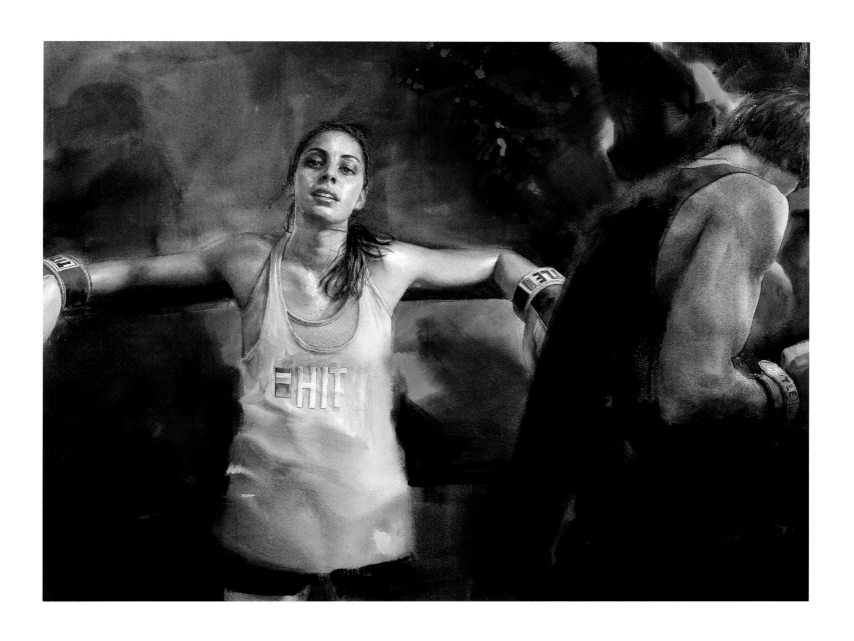

Chance, casino dealer
Watercolor on paper, 28 × 35 inches, 2017
Tracy, Henderson, Nevada
Air Force E-3, 1987–90

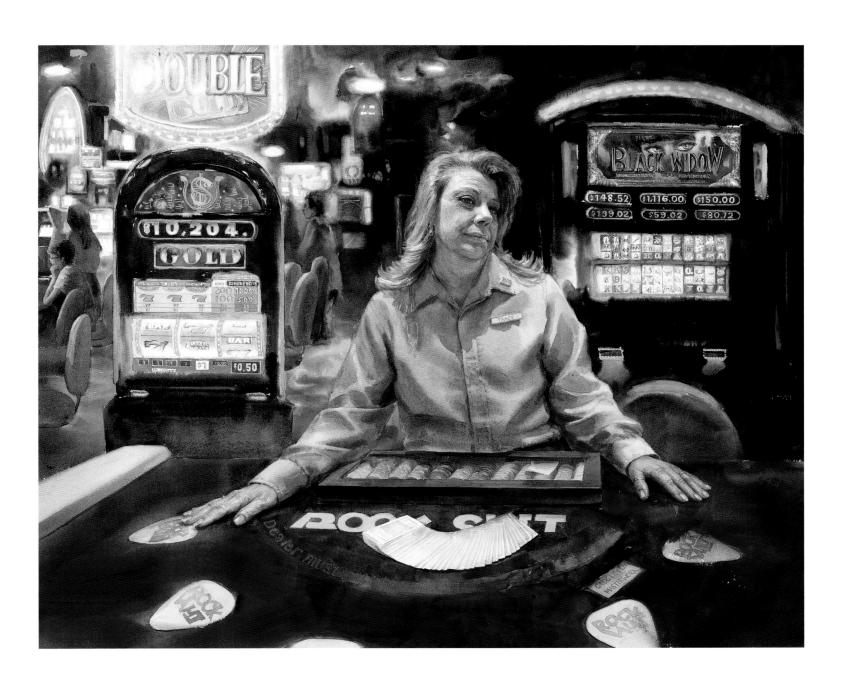

Cloister, chair maker
Watercolor on paper, 36.25 × 28.25 inches, 2014
George, Marlboro, New Hampshire
Marines Staff Sergeant, 1942–45
Reserves Tech Sergeant 1946–52

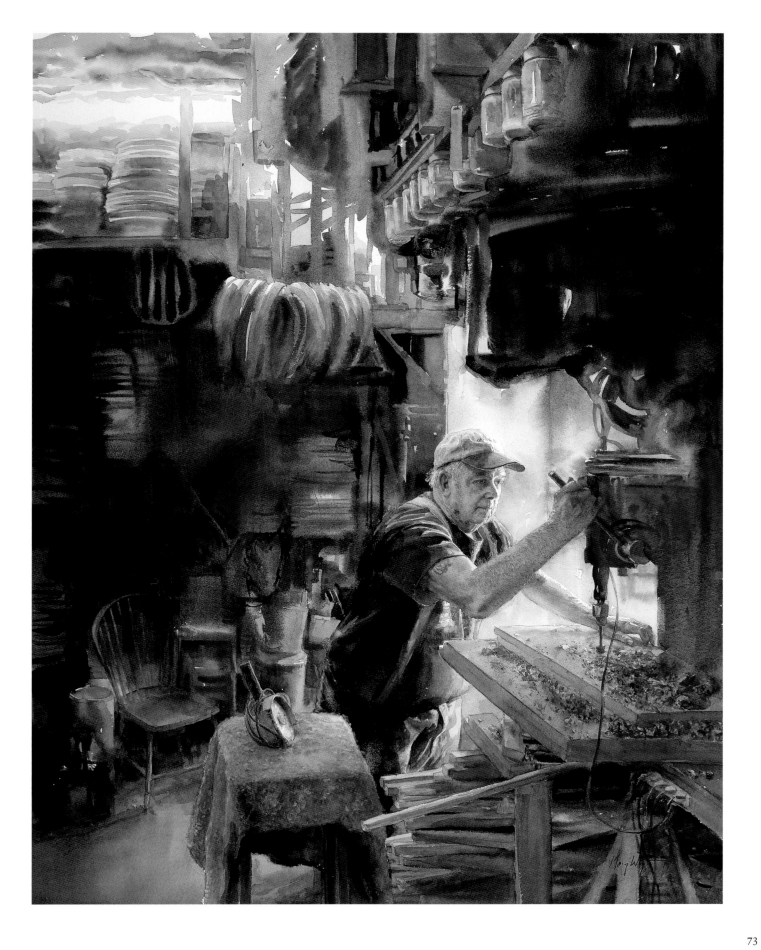

Tomato Pie, gardener
Watercolor on paper, 40 × 60 inches, 2016
Hank, South Plainfield, New Jersey
Coast Guard BM First Class, 1942–46

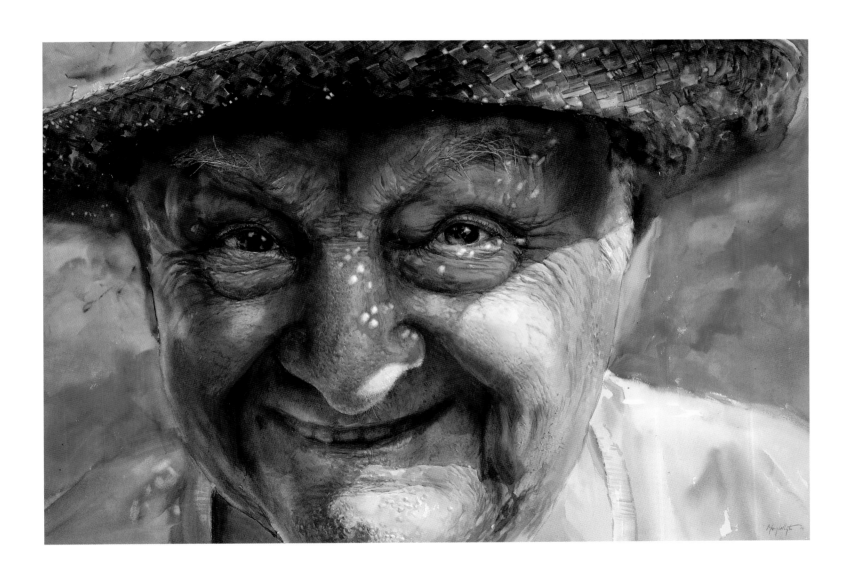

Flurries, rancher
Watercolor on paper, 23.375 × 31 inches, 2012
Dogie, Watrous, New Mexico
Navy Seaman First Class, 1943–46

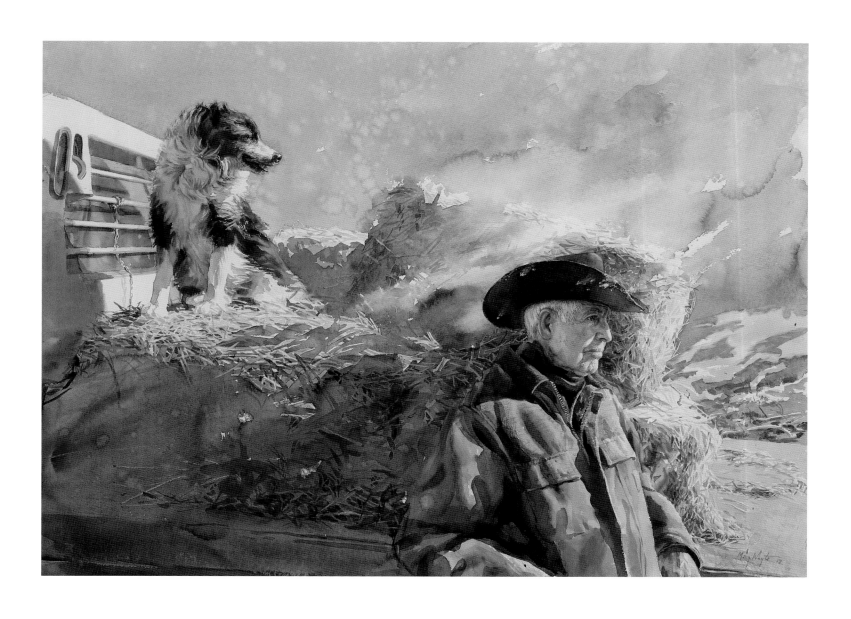

Multitude, taxi driver
Watercolor on paper, 48 × 47.25 inches, 2016
John, Queens, New York
Army Private 1974–75

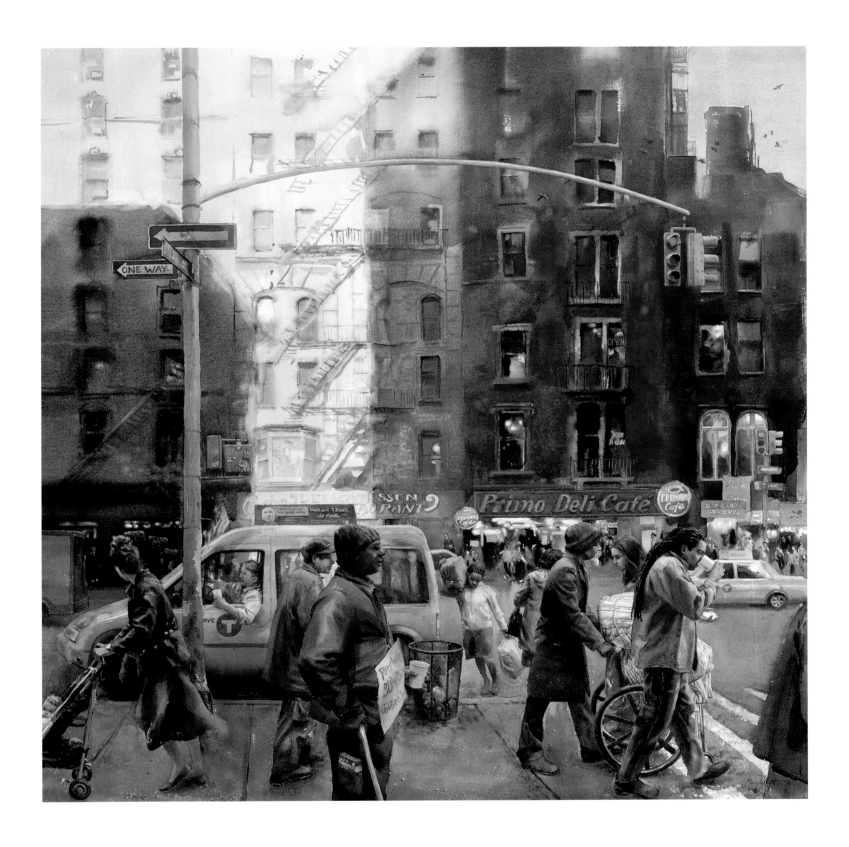

Archangel, athlete
Watercolor on paper, 39.375 × 58.375 inches, 2018
Edward, Stella, North Carolina
Marines Staff Sergeant, 1988–2000
Army National Guard First Lieutenant, 2000–2005

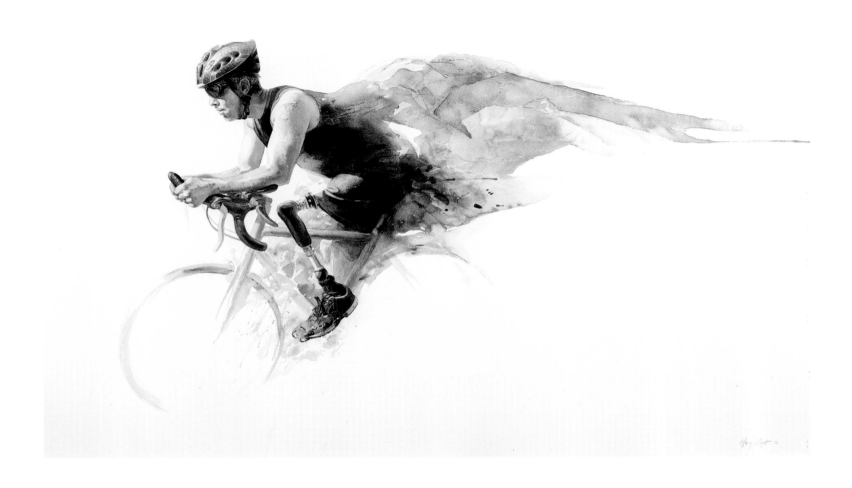

Partial Eclipse, plumber
Watercolor on paper, 28.875 × 23 inches, 2017
Jeff, Fargo, North Dakota
Army National Guard Sergeant E-5, 1982–96

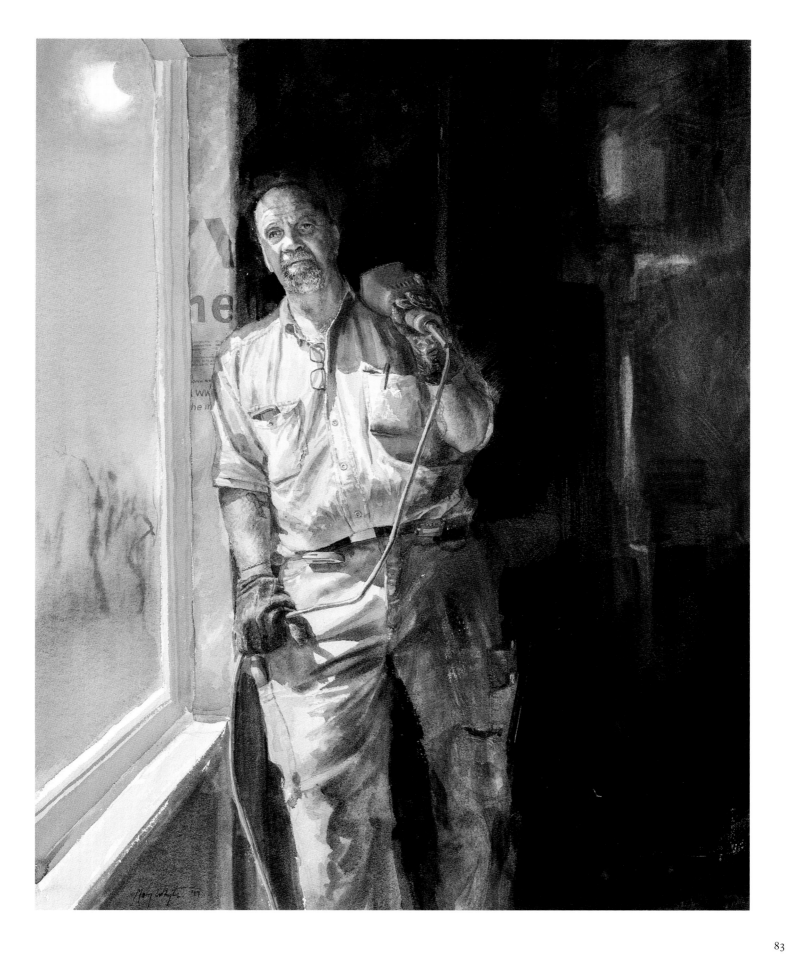

Long Haul, truck driver
Watercolor on paper, 35.75 × 28.50 inches, 2015
Sondra, Toledo, Ohio
Marines Lance Corporal E-4, 1968–69

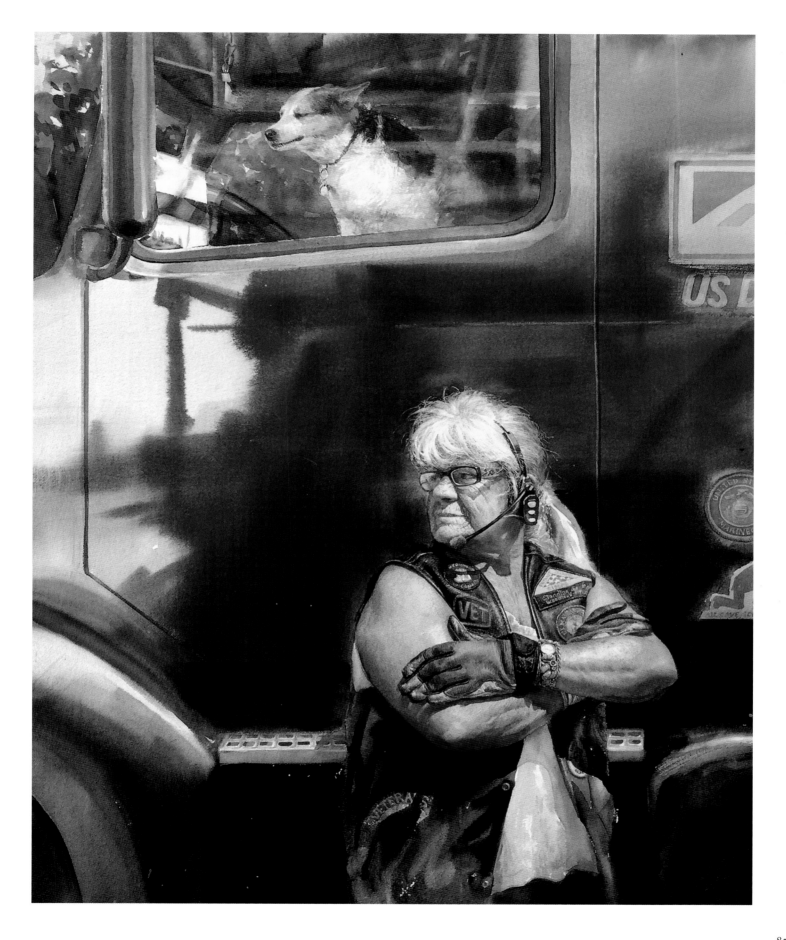

Requiem, motorcycle hearse transport
Watercolor on paper, 28.25 × 28.125 inches, 2016
Brian, Okarche, Oklahoma
Army E-4, 1984–88
Army National Reserves, 1988–92

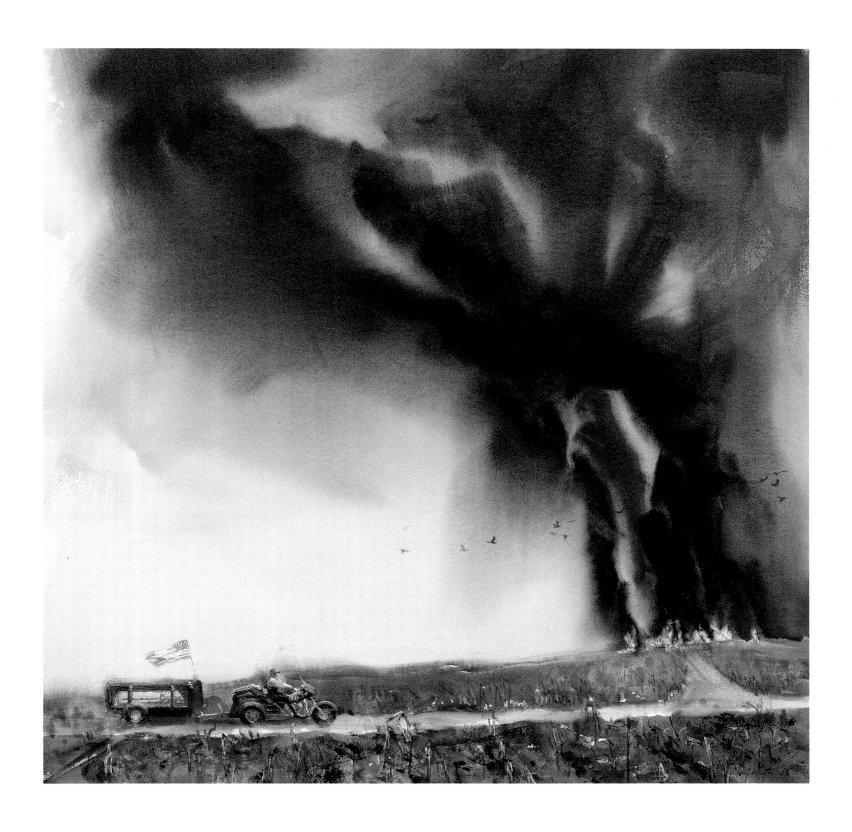

Battleground, firefighter
Watercolor on paper, 40.75 × 28.75 inches, 2012
Casey, Bend, Oregon
Army Sergeant A-5, 19th SFG, 2001–

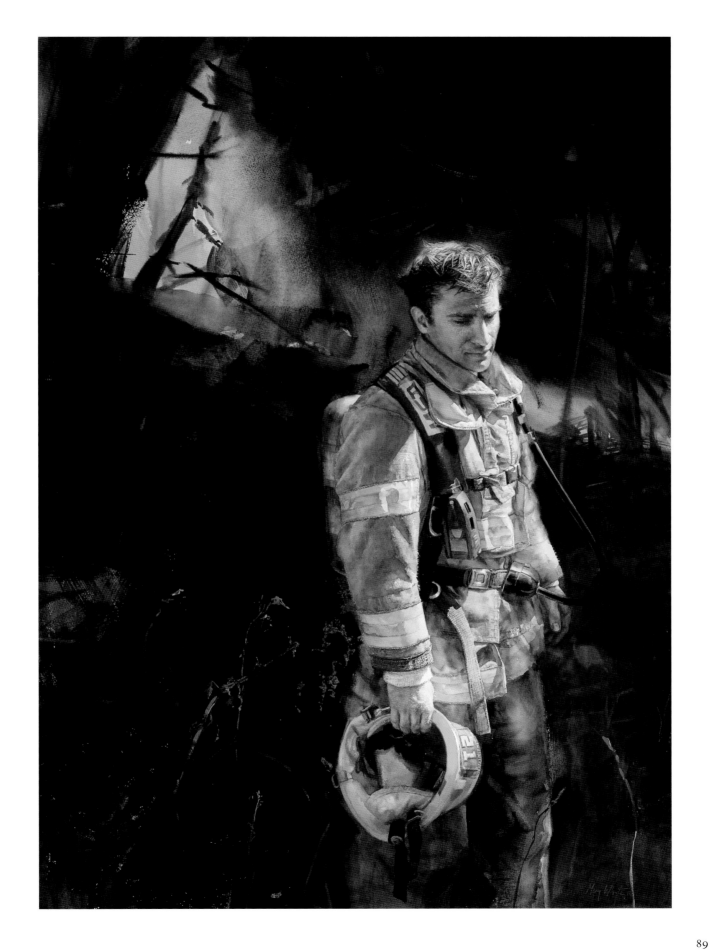

Evolution

Evolution, junior high science teacher
Watercolor on paper, 28.875 × 32.5 inches, 2016
Richard, Telford, Pennsylvania
Navy Captain, 1986–2008

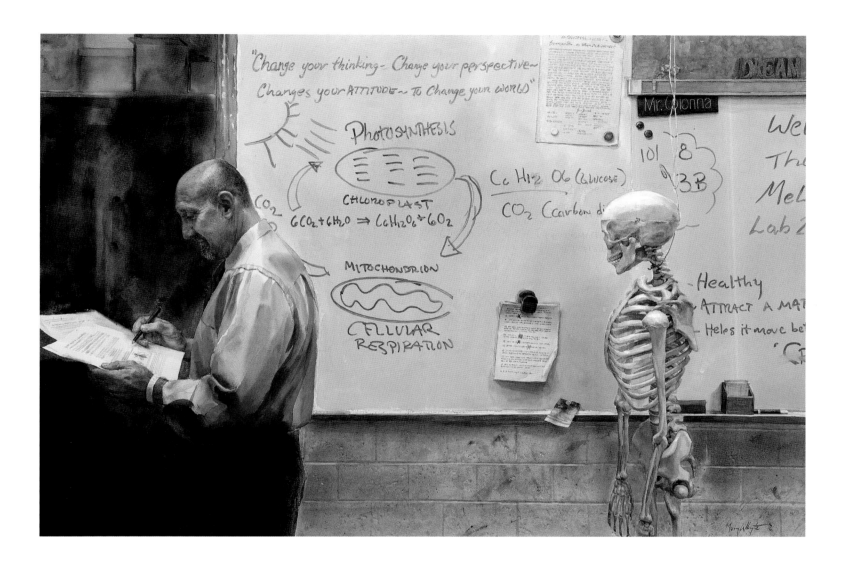

Hauling, lobsterman
Watercolor on paper, 24.5 × 29 inches, 2012
James, Little Compton, Rhode Island
Naval Reserves 1968–72
Active duty Navy BM Second Class 1972–74

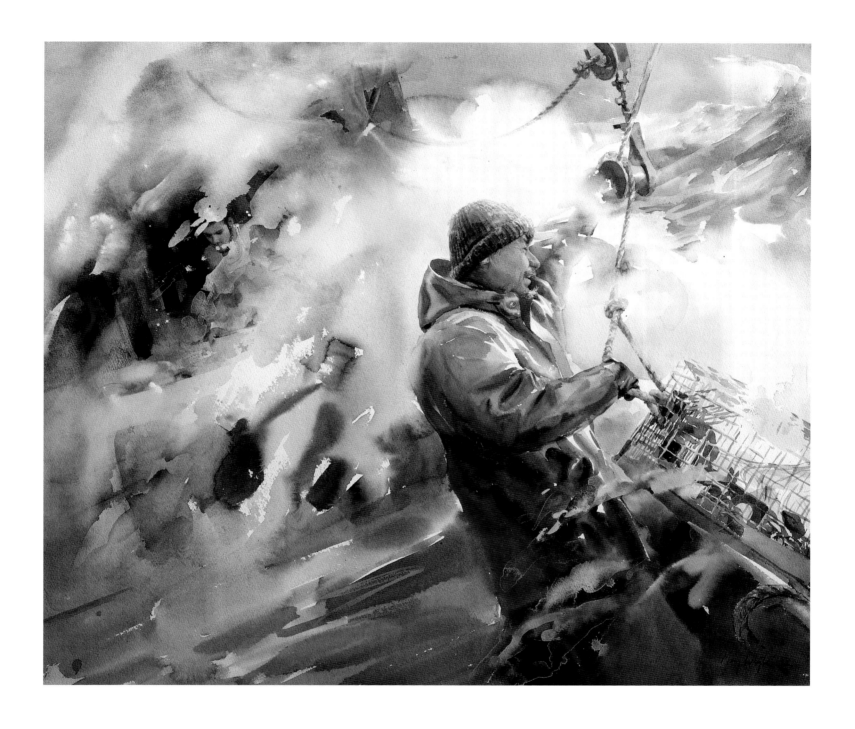

Family, single mother
Watercolor on paper, 29 × 27.5 inches, 2018
Tynaya, Hanahan, South Carolina
Marines E-4, 2006–2009

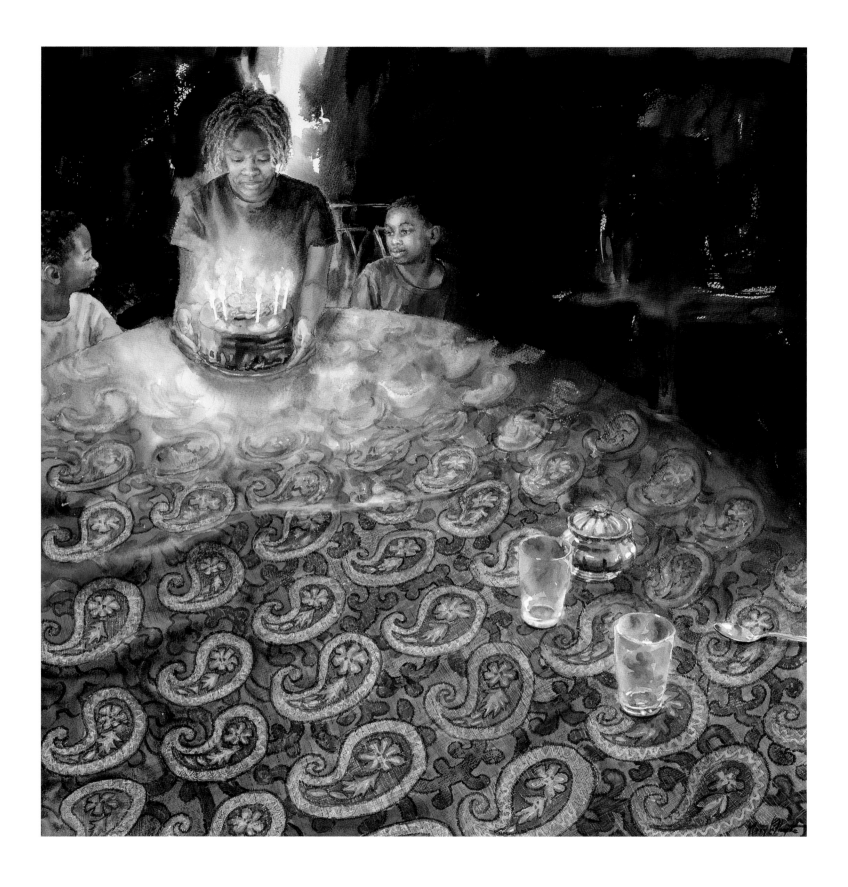

America

America, Native American traditional dancer
Watercolor on paper, 40 × 53 inches, 2017
Kella, Aberdeen, South Dakota
Army SP4, 1986–88

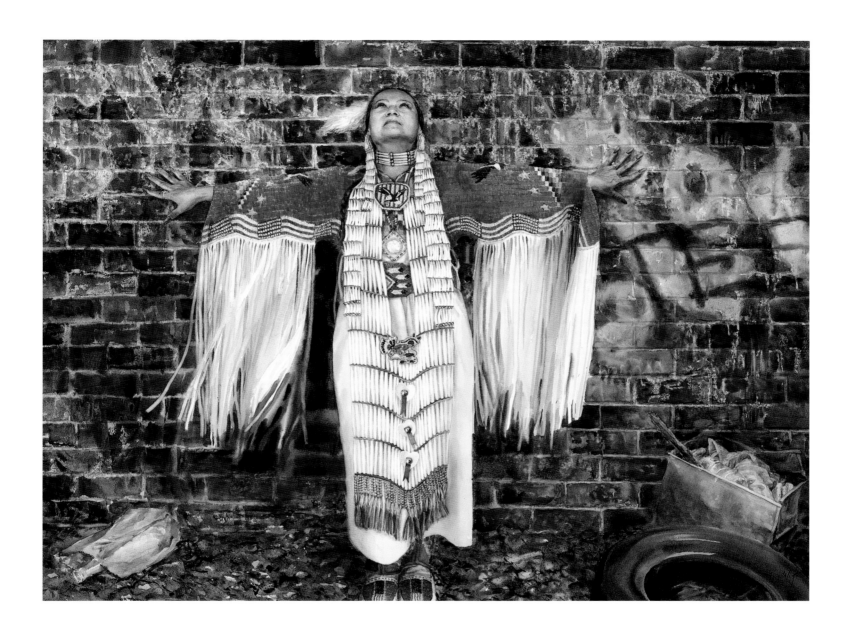

Manhood, barbers
Watercolor on paper, 28.5 × 26.25 inches, 2015
Jason, Blountville, Tennessee
Marines Lance Corporal E-3, 1999–2002
Daniel (shown in mirror), Kingsport, Tennessee
Army Specialist E-4, 1990–95

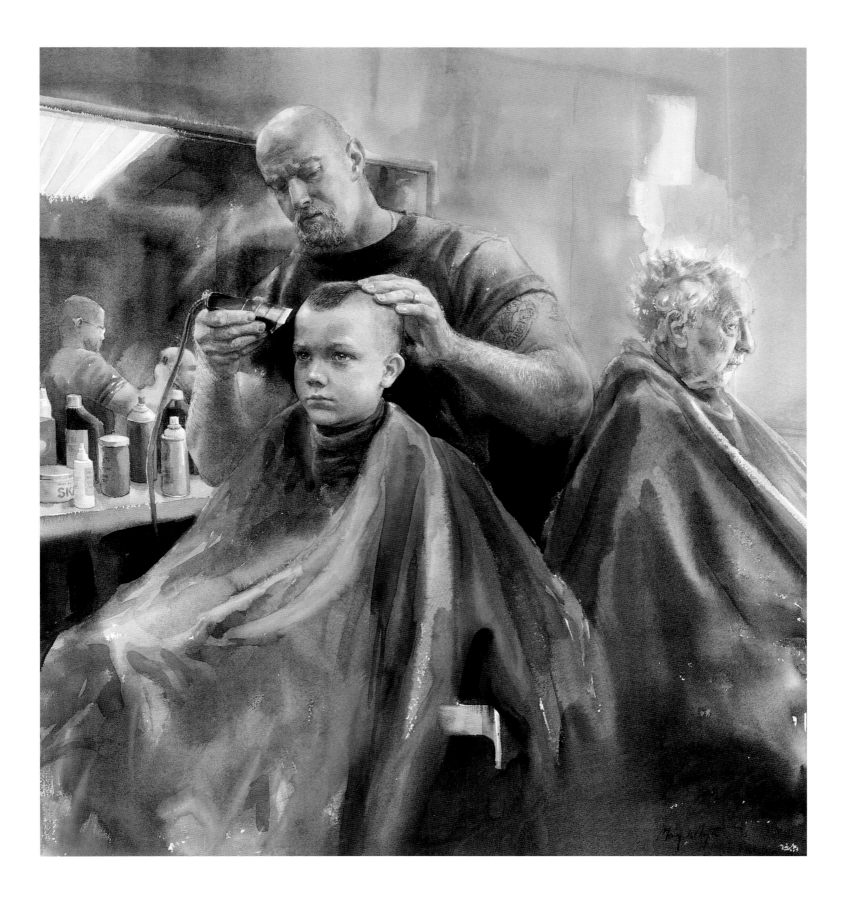

Counterbalance, construction worker
Watercolor on paper, 30.625 × 38.5 inches, 2018
Joanie, Houston, Texas
Army Sergeant, 2008–2016

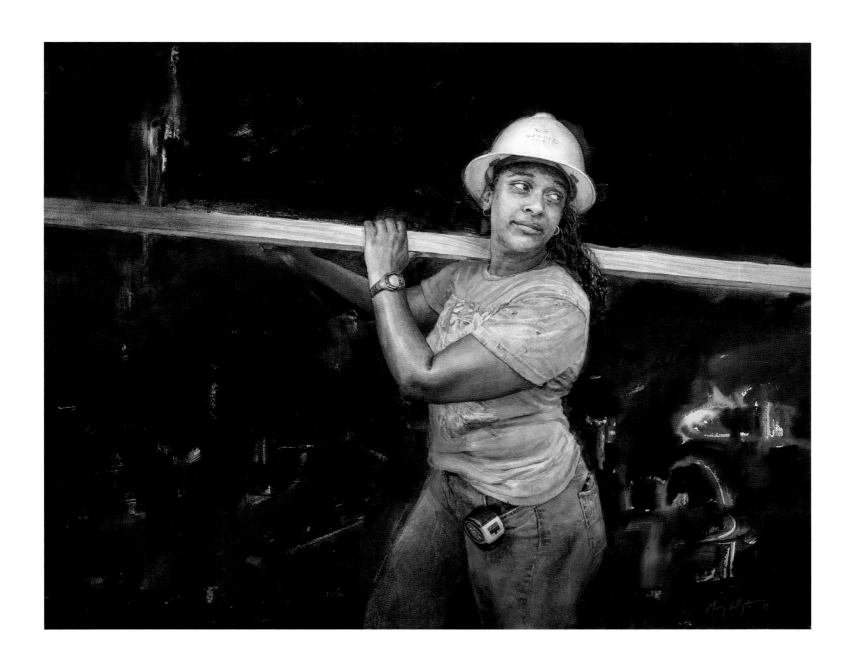

Commander, business woman
Watercolor on paper, 31 × 28 inches, 2017
Celeste, Salt Lake City, Utah
Army National Reserves Specialist, 1981–87

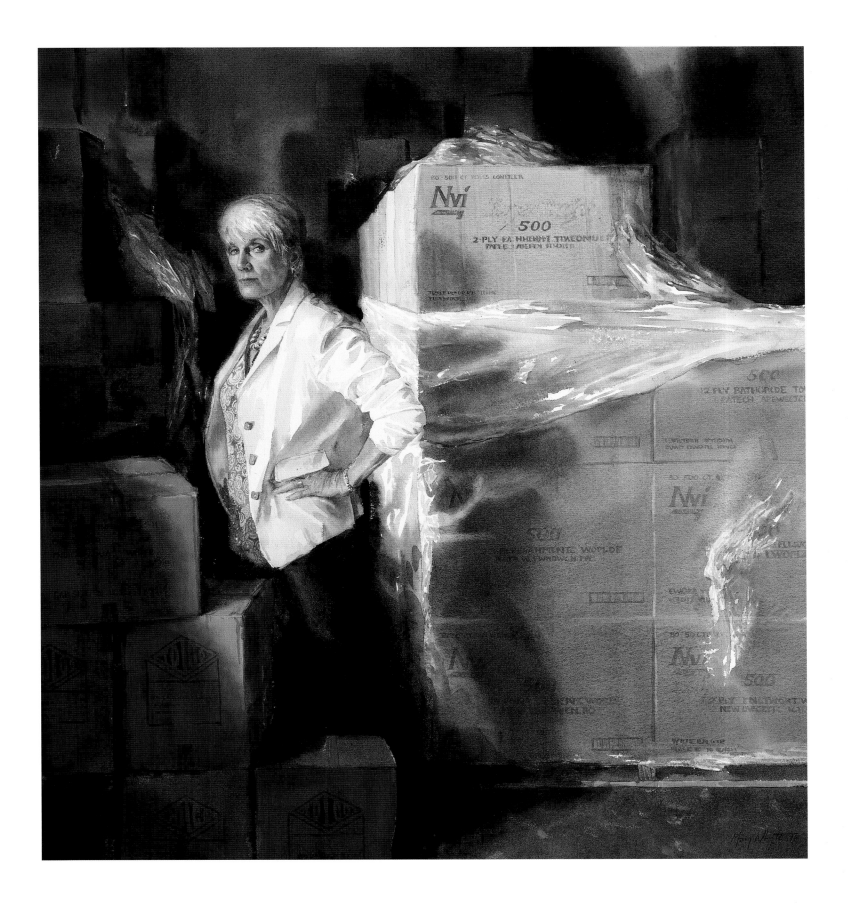

King of Junk, flea-market vendor
Watercolor on paper, 27.5 × 27.5 inches, 2015
David, Bennington, Vermont
Navy BT3, 1966–72

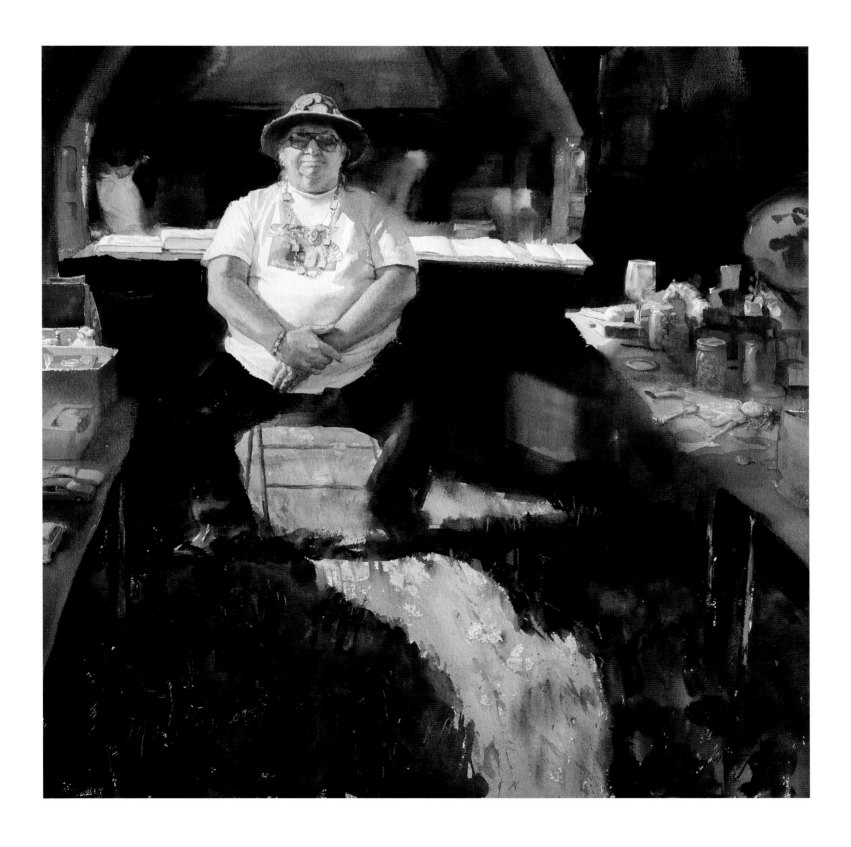

Piecework, hand-sewing specialist
Watercolor on paper, 48 × 39.5 inches, 2015
Jean, Richmond, Virginia
Navy Yeoman E-1, 1970–71

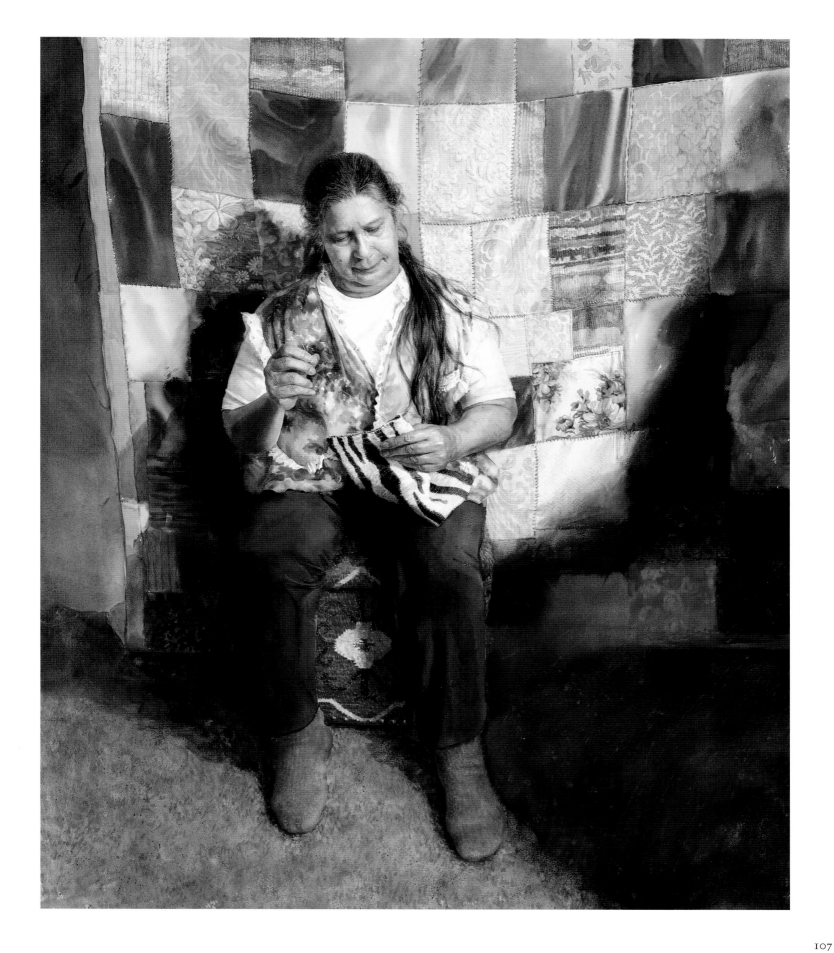

Midnight, nurse
Watercolor on paper, 27 × 34.5 inches, 2015
Grethe, Langley, Washington
Army Colonel, 1961–68, 1972–97

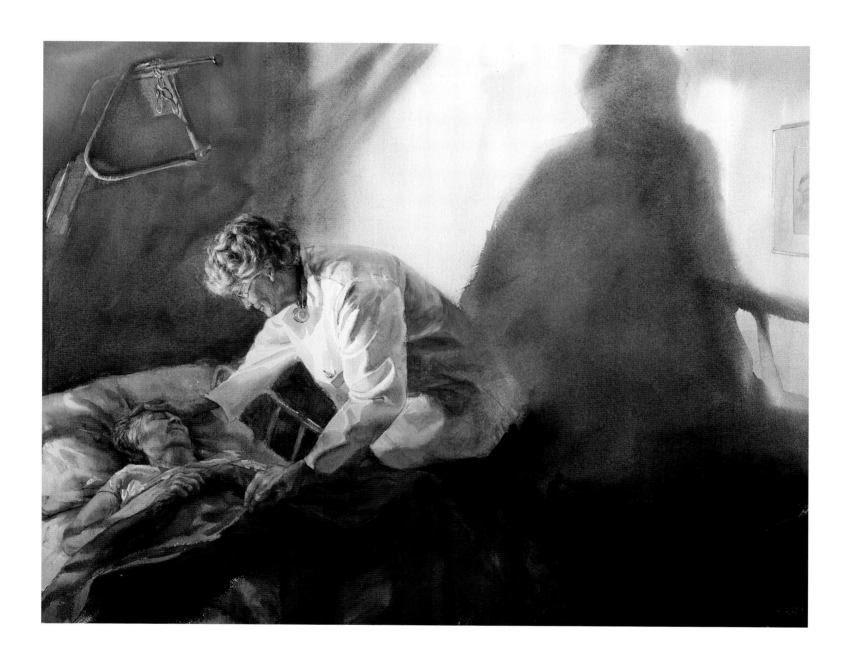

Subterranean, coal miner
Watercolor on paper, 60 × 40 inches, 2017
Allen, West Logan, West Virginia
National Guard, 1994–97
Army Sergeant E-5, 1997–2001

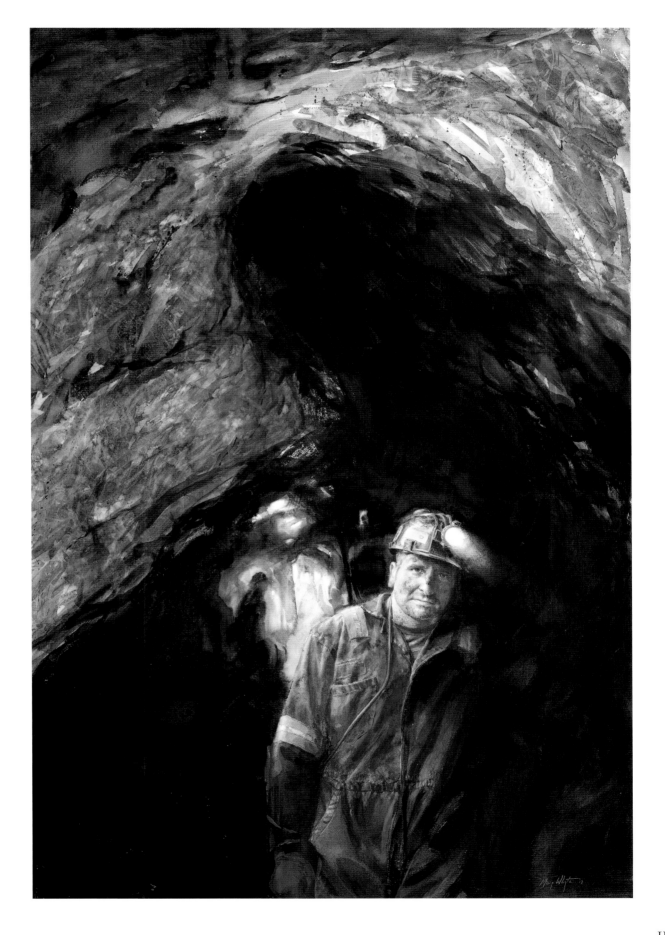

Crossing Over, ferryboat captain
Watercolor on paper, 28.5 × 22.25 inches, 2016
Michael, La Pointe, Wisconsin
Army National Guard Specialist, 2013–

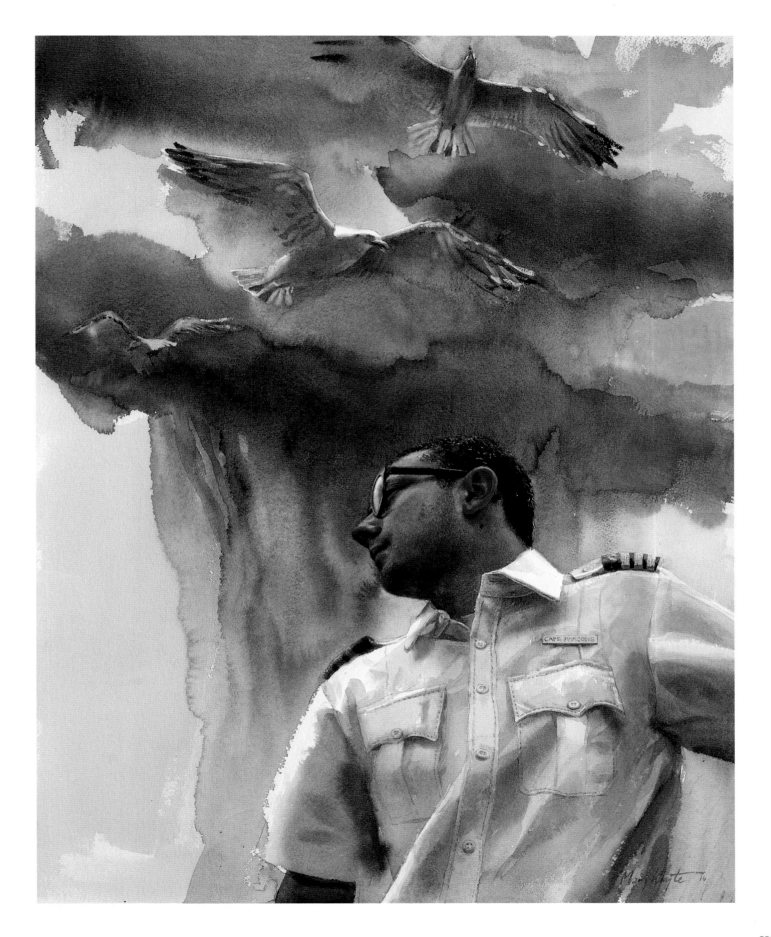

Aspen Leaf, groundskeeper
Watercolor on paper, 19 × 28.5 inches, 2014
Don, Jackson, Wyoming
Navy Patrol Plane Commander, 1950–55

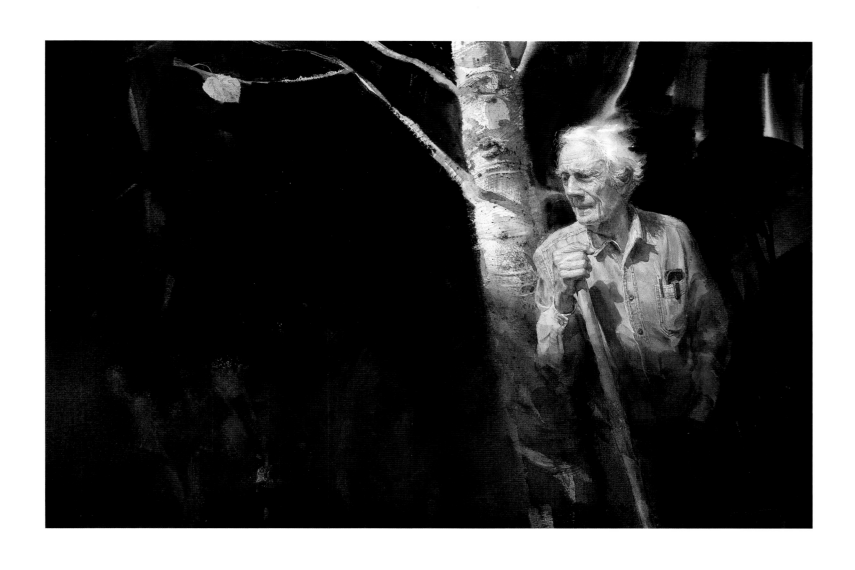

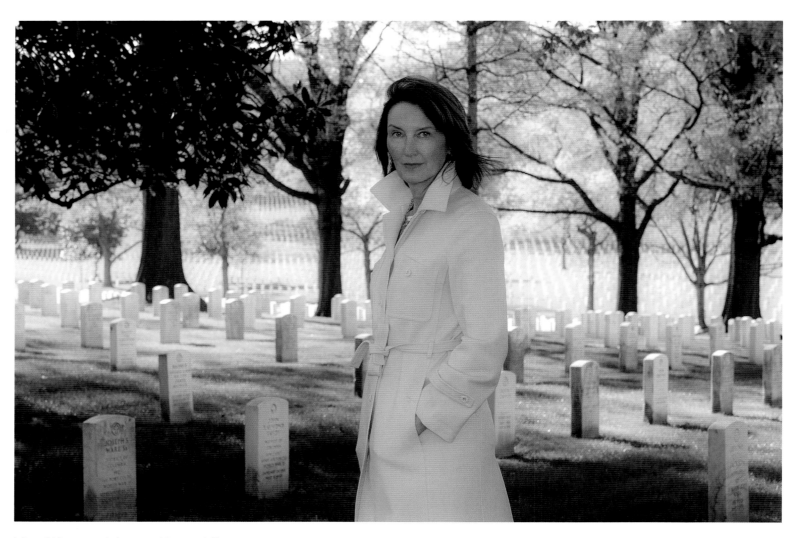

Mary Whyte at Arlington National Cemetery.
Photograph by Jack Atlerman.

"And he shall judge among the nations, and shall rebuke many people: and they shall beat their swords into plowshares, and their spears into pruninghooks: nation shall not lift up sword against nation, neither shall they learn war any more."

ISAIAH 2:4

INDEX OF PAINTINGS